The Magic of Digital
Nature Photography
Second Edition

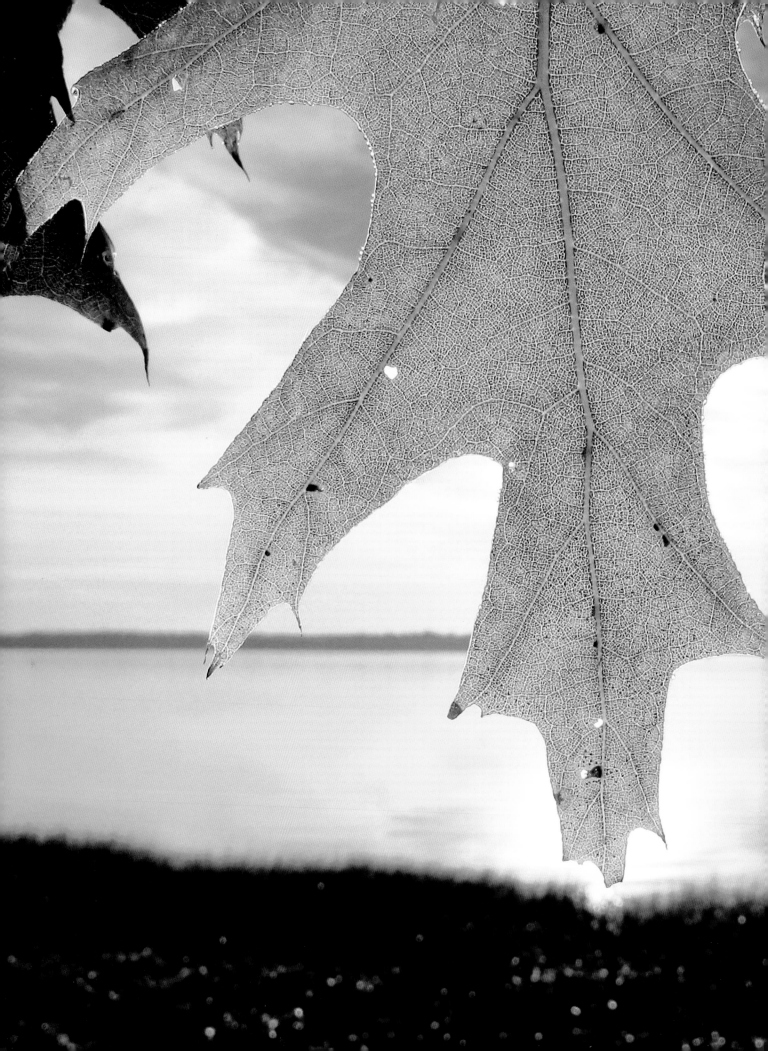

The Magic of Digital
Nature Photography
Second Edition

Rob Sheppard

PIXIQ

67 Broadway
Asheville, NC 28801

Text and photographs © 2013 by Rob Sheppard
This is a completely revised and updated edition of a previous book by this title

ISBN 978-1-4547-0813-1

Library of Congress Cataloging-in-Publication Data

Sheppard, Rob.
 The magic of digital nature photography / Rob Sheppard. -- Second edition.
 pages cm
 Includes index.
 ISBN 978-1-4547-0813-1
 1. Nature photography. 2. Photography--Digital techniques. I. Title.
 TR721.S53 2013
 779'.36--dc23
 2012031276

Distributed in Canada by Sterling Publishing
c/o Canadian Manda Group, 165 Dufferin Street
Toronto, Ontario, Canada M6K 3H6
Distributed in the United Kingdom by GMC Distribution Services
Castle Place, 166 High Street, Lewes, East Sussex, England BN7 1XU
Distributed in Australia by Capricorn Link (Australia) Pty. Ltd.
P.O. Box 704, Windsor, NSW 2756, Australia

For information about custom editions, special sales, and premium and corporate purchases, please
contact Sterling Special Sales at 800-805-5489 or specialsales@sterlingpublishing.com.

Email academic@larkbooks.com for information about desk and examination copies.
The complete policy can be found at larkcrafts.com.

Manufactured in China

2 4 6 8 10 9 7 5 3

sterlingpublishing.com

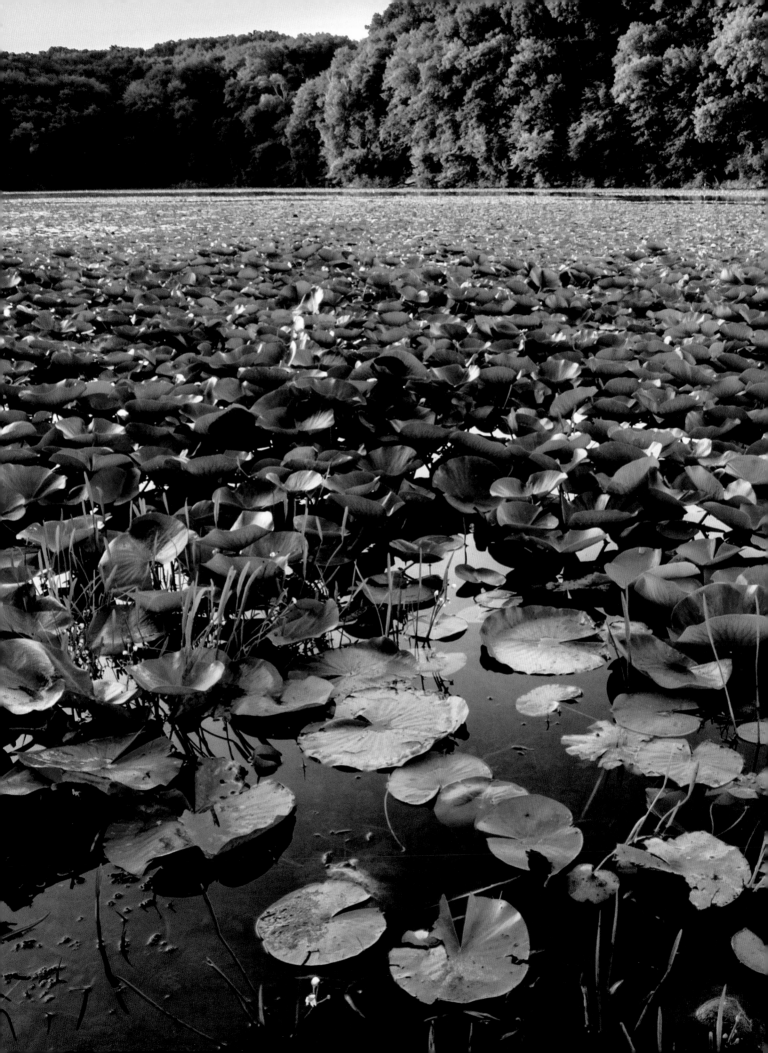

contents

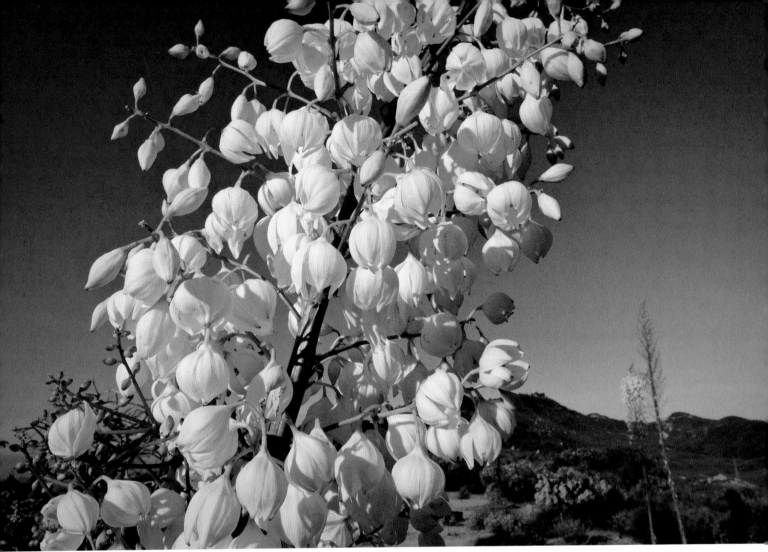

Chaparral yucca in bloom, Santa Monica Mountains, California

Introduction

I have enjoyed photographing nature since I was a kid. I remember entering a black-and-white print of lower Gooseberry Falls in Northern Minnesota into a local newspaper's photo contest when I was in junior high. I was very proud of that photo, but it didn't win. That really didn't matter, for being outside with a camera was a real joy.

And it still is. I have photographed from Peru to Newfoundland, Florida to Washington, and I have loved it all. There is a magic to being outside in a beautiful location and photographing the nature that surrounds you.

This new edition is my way of sharing that magic and to give you ideas on how to capture the magic of nature in your own photography. The book is updated with fresh information in Chapter 2 because so much of digital photography has changed since this book first came out. I have updated wherever necessary in the rest of the book, but the core ideas of nature photography have not changed. You will find a large number of new photos, though, because I want to encourage the idea that nature photography deserves fresh images along with the old. I love Ansel Adams still, but I also enjoy seeing the work of new and upcoming nature photographers such as Ian Shive and Mac Stone.

I have included techniques and ways of photographing natural subjects that I know work because they have worked for me and for my workshop students. You will find a range of ideas, from those basic things beginners need to new possibilities that might encourage an expert to try something new. You will also see many of my favorite subjects. For me, nature photography is a way of sharing a part of the world that I care very much about. I want viewers to discover anew the neat bits of nature that I have discovered in many great locations, from the dramatic places most of us visit only once, down to the special little places that harbor nature right outside your door.

I don't want to simply share these subjects with you. I want to get you excited about getting out and taking photographs of your own special subjects. We all have them. You don't have to photograph like Ansel Adams in order to find your vision of nature through photography. The key is to get out and experiment. I believe there is a certain restorative power that comes from being outside connected to nature through your photography. To take nature photos, you have to be in nature. Being in nature connects you with the world in ways that no nature documentary, Internet website, or realistic game can ever do. In today's world, I believe that connection is very important to us all.

So whatever your inclination for photography, enjoy the book, then get out and make your own photographs. Have fun exploring nature wherever you are!

Rob Sheppard

www.natureandphotography.com

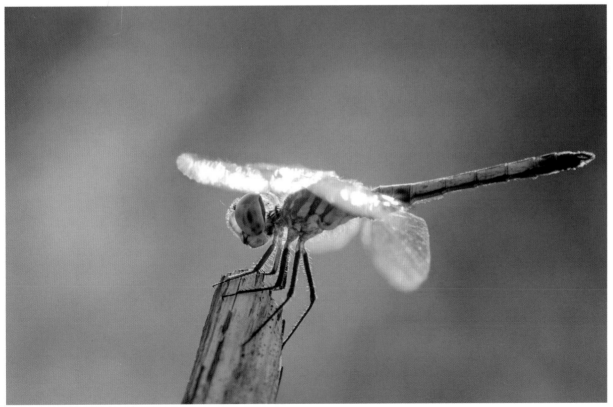

Dragonfly, Southern Illinois

Possibilities

1

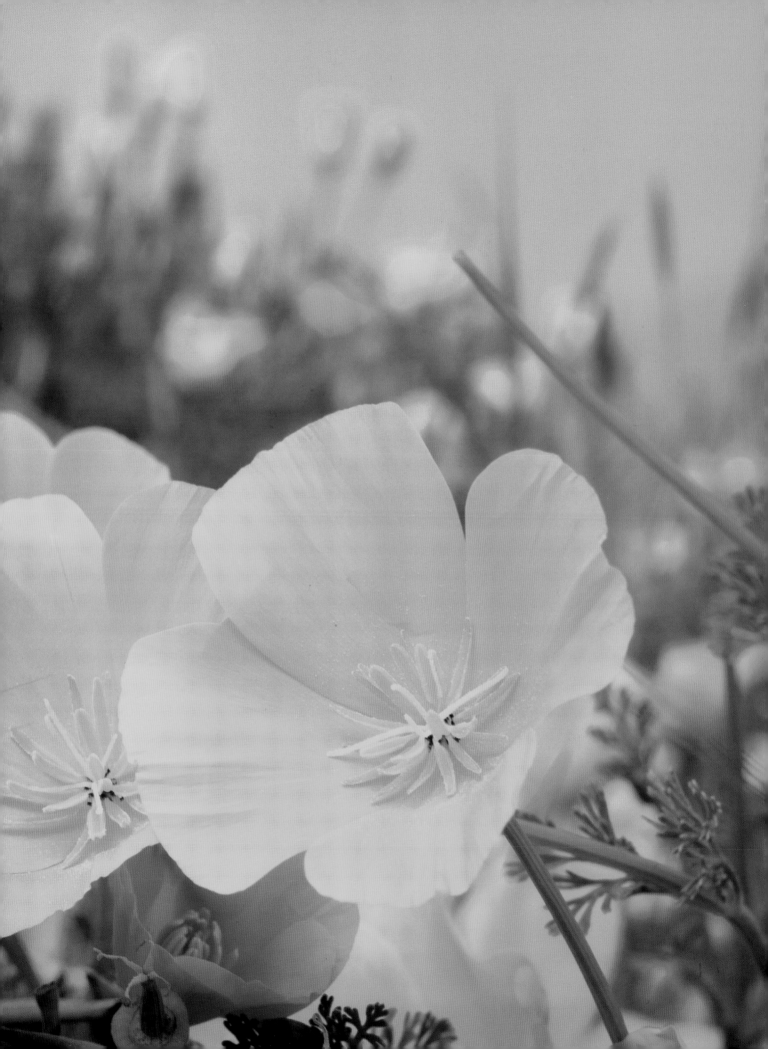

Who hasn't been excited by a stunning sunset and wanted to capture that as a photograph? Or who has visited a great landscape and hasn't wanted to share that with others?

Almost everyone who owns a camera has photographed nature. It has been a subject for photographers since photography began.

Nature attracts us with its beauty, grandeur, wildness, ability to provide refuge from our often hectic lives, and for its magic. The natural world holds so many wonderful and amazing things it definitely seems magical at times. Nature photography gives us the chance to experience and interact with another kind of magic: the ability to realistically capture the world in a still image.

I have to let you in on something about nature photography that not everyone talks about. Nature photography will transform you. This is no psycho-babble. It has affected me, true, but that would hardly be enough evidence to say it will transform anyone. I say this because I have seen it to be true time and time again. As the former editor of *Outdoor Photographer* magazine, I have had the privilege to know some of the great nature photographers of our time. For them, consistently, photographing nature is not simply about capturing a subject, but about connecting with the life around them to affect both the photographer and the viewer. Richard Louv spells this out pretty clearly in his book, *The Nature Principle*.

Nature photography lets us escape the challenges of our world and gives us the chance to share our unique experiences in the natural world. Whether we just like the color of a special flower, the drama of a mountain range, or want to alert others to environmental issues, nature photography is a great way to express a feeling. No matter your skill level as a photographer, capturing nature in photos is a special experience that goes far beyond the photography itself.

Anne Lamont, author of *Bird by Bird*, a book about writing, says something that applies to nature photography, too. She answers the question about why writing matters. Her answer, I believe, fits nature photography perfectly: " *. . . because of the spirit . . . because of the heart. Writing and reading . . . deepen and widen and expand our sense of life: they feed the soul.*"

Nature photography definitely deepens, widens, and expands our sense of life. And I know from working with so many nature photographers that it feeds the soul. Ultimately nature photography comes back to you, the photographer. What do you love about nature, and how can you capture that on film? What is life affirming and soul expanding about nature for you?

Overleaf (previous page): California poppies, Montana de Oro State Park, California

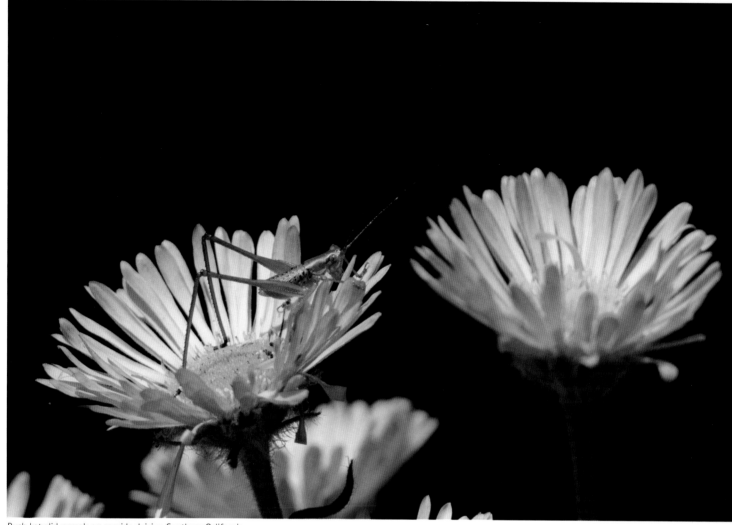

Bush katydid nymph on seaside daisies, Southern California

Appreciation

The natural world is home to a wealth of wonderful elements, from sunsets over the ocean to dew drops on a spider web. There is much to appreciate, but of course, what you like about nature doesn't have to be the same as someone else's preferences. That is what makes nature photography so exciting; you can take pictures of your favorite subjects and have totally different images than someone else with a different set of favorites.

Author Bill McKibbon once wrote, in a well-intentioned but sadly misguided article, that no more wildlife photographs were needed, so photographers could quit bothering animals. That misses one of the beautiful parts of nature photography—the actual process of photography is an act of appreciation and enjoyment, and that process nurtures feelings of appreciation for nature. (Having worked as a naturalist, I can also note that while it is possible to bother animals, the natural world is far more threatening to a wild animal than a caring photographer.)

You don't have to be a National Geographic photographer to appreciate nature through your camera. Let your own loves and joys from experiencing nature, whether in a neighborhood park or the Grand Canyon, guide you to beautiful images that you can call your own.

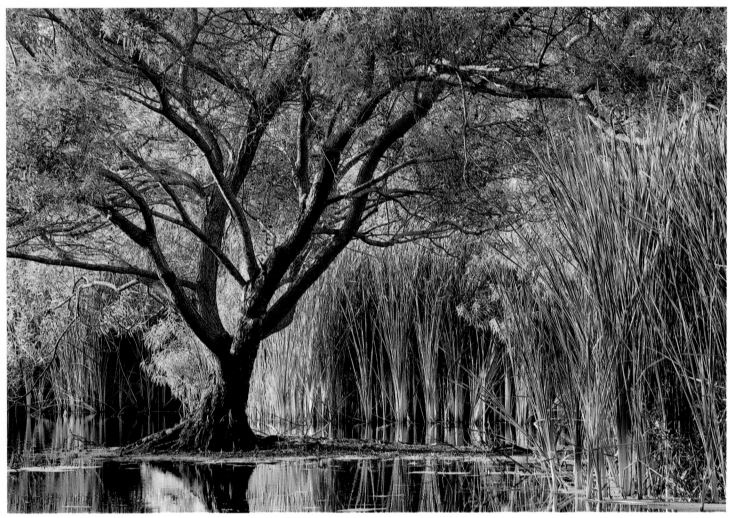

Marsh, Southern California

Recording Memories

A very basic and important part of photography is its ability to record things for posterity. When you go to a great location like Yellowstone National Park, or experience autumn in Acadia National Park, you want to remember it. Some of your photos will be just for the record, so to speak.

Today's cameras do a very good job of record keeping. Modern exposure systems, autofocus, zoom lenses, and more all give us the ability to go to a great location and record at least a reasonable facsimile of it. These will not be the shots that you will put on your wall or proudly show off to everyone as examples of your photographic skills, but if you don't take these photos, you will miss them when you get home.

Even Hollywood includes such shots in the best of films. An overall composition of the setting in which the action takes place helps the viewer better understand the context of the scene. The same thing applies to your photography. Overall shots that record the setting can give the rest of your photos some context, too. At a minimum, they help you better remember the location and provide context for a slide show.

Connections

One of the real challenges of modern civilization is the loss of connection with the natural world. Even if we live in the city, nature still affects our lives in many ways. In general, most people need something of nature around them. We consider architectural spaces without plants to be sterile and uninviting.

We have many connections to the natural world, though they aren't always recognized. The rush of spring growth and its wonderful greens has a positive boost on nearly everyone. The weather around our homes is affected by the natural plants there; trees, for example, keep streets cooler in the summer. For many people, feeling connected to nature has spiritual connotations—on a very basic level, who has not felt emotionally uplifted when standing in a field of flowers?

Photography is a superb way to connect with nature, and it works in three ways:

1. Connecting with the subject when you take the picture—When you take a picture of something in nature, you discover wonderful things that you love about our world. Finding a way to explore that through the viewfinder can be a way of focusing your attention, too.

2. Connecting again with the subject when you look at the photo later—That great subject you saw outside can be experienced and enjoyed again when you make a print or see it on your computer screen. It can help you relive the whole experience of being there with something in nature.

3. Helping others connect with the subject when you share the image—A great part of photography is the chance to share what we see and love with others. Once other people see your photos, they, too, have a chance to connect with that subject and gain something from that connection.

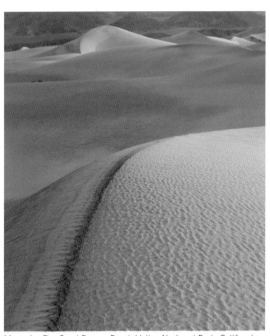

Mesquite Flat Sand Dunes, Death Valley National Park, California

Red eft (land form of newt), Vermont

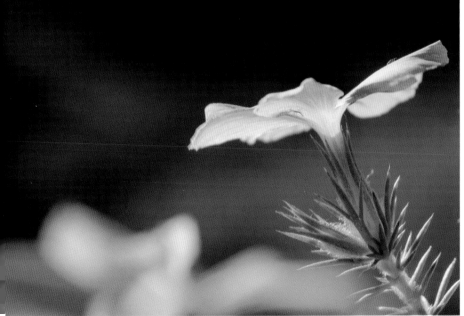

Prickly phlox, Santa Monica Mountains, California

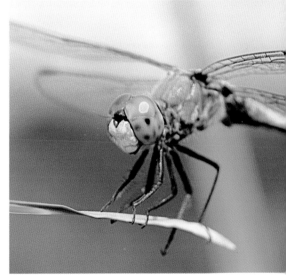

Dragonfly, New Mexico

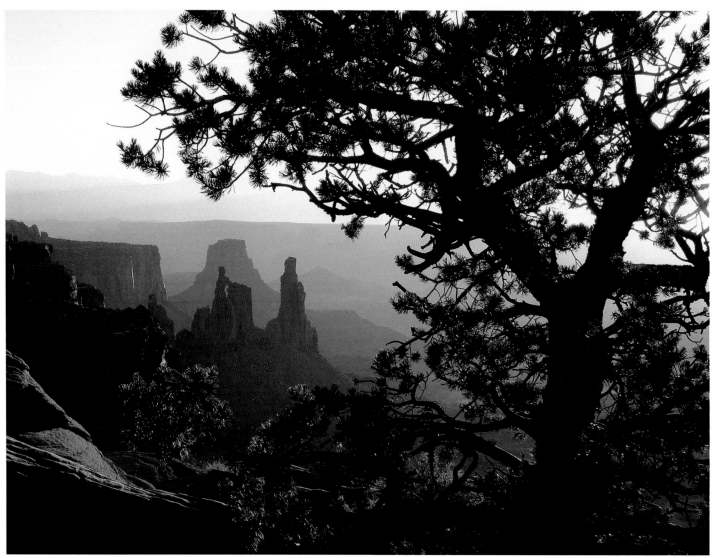
Canyonlands National Park, Utah

Sharing Your World

Let's explore the idea of sharing and why it is important. After all, that is the whole purpose of publications like *National Geographic* and *BBC Wildlife* magazines. They share images and ideas about natural things from around the world.

You can do that, too. I think this is an essential part of photography. When you photograph things in nature, I know that you feel something about that subject. When traveling, we often photograph things just to remember them. But a sunrise through the woods, richly colored flowers, or a pelican flying close to the water all provide something more. We take those pictures when we are inspired by the subject.

When we share photos with others, whether attached to an email or put into a slideshow with music and special effects, we are sharing our excitement about the world. This is always worth doing, no matter what level of photographer you are. I sometimes hear amateurs making excuses for their photographs and not wanting to show them. Share those photos! The natural world is a special place and by sharing your special connection to it through your images you offer others new possibilities and insights to that world. No one sees the world exactly as you do.

As your skills improve, your photographs will become more refined and crafted, but the core belief in your subjects won't change. That is there from the start and is always worth sharing with others.

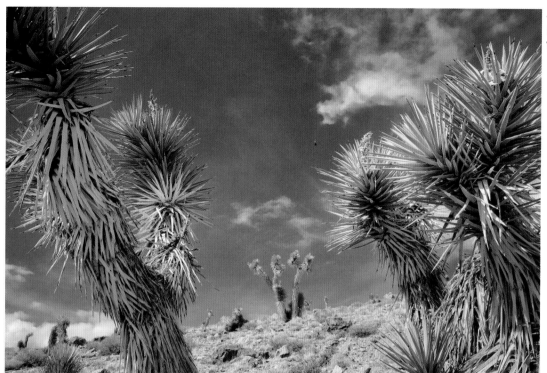

Joshua trees (left) and desert pupfish (below), both in Death Valley National Park, California

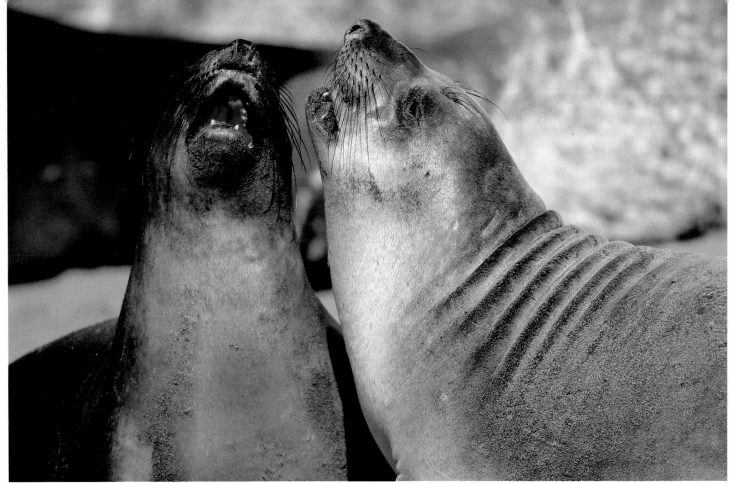

Young elephant seals fighting, California

Creative Expression

Nature is full of creativity. Think of the brilliance of autumn colors painted across a hillside, the beautiful colors of a wood duck, or the clever way a Venus flytrap plant captures its insect prey. Those scenes can be very inspirational, and you can certainly photograph them. But for most photographers, creative expression means much more. We want to make something beautiful and unique—a photograph that we can proudly display on the wall or an image that no one else has.

There are so many possibilities here. This book is filled with them and is meant to offer you ideas and inspiration for your own picture-taking. But there is a challenge. Sometimes nature just looks so good that it distracts from the photography! For example, a beautiful flower is so perfect that it seems all you should do is frame it with the camera and take the picture. Nature may be perfect, but the camera isn't. The problem is the camera doesn't see the world the way we do. We have to control things like light, focus, and background to create an image that expresses the essence of the flower. This is creative expression.

One way to awaken your creativity with nature photography is to adopt a playful or experimental approach to picture-taking. Digital cameras make taking well-exposed, properly focused photos a lot easier than in the past. Plus, you can instantly check any of your shots to see if you like them or not by using the camera's LCD. The technical part of the process has been nicely simplified and adjusted for us so we can concentrate on other things. Now you can go beyond just framing that interesting natural scene in the viewfinder.

Take the first picture you see, for sure, but then take another. Go beyond that first image and find something else interesting about your subject. Use the LCD to review and compare shots. There is always something else. Try a higher or lower angle of view. Get closer or farther away. Shoot through some leaves or look for a natural frame. Play with your photography and your subject. Look at your results in Playback mode with a critical eye and don't be afraid to re-shoot. The whole digital process is creatively liberating because there is no cost to recording multiple images on your memory card.

Understanding

Photographs can help unveil the secrets and mysteries of nature. For that reason, scientists have used photography for years to aid in the study of subjects. Photographing nature can help us discover and understand the things we see in the world. In addition, photos are perfect for helping all of us remember special things we've seen. What did that contorted tree look like up in the mountains? Bring out the photos and see. How big were the fields of California poppies that year? Pull up the image files on the computer and check.

Nature studies cover many areas, from the complex fieldwork of a professional ecologist to the casual observations of a birding enthusiast. Photography helps both, providing tools to capture images representative of their subject so they can later identify the subject, compare it to others, check unique characteristics, place it in a special location, and so forth.

Photography for nature studies, however, can be quite different than photography for creative expression. Scientists, for example, need a photograph that is clear and sharp so that special details of the subject are easily discerned. No creative lighting is necessary. Even an amateur naturalist will often need a more scientific photo that allows the subject to be readily identified.

There is certainly a place for both types of photography. If I find a flower that I don't know, for example, I often try to take a photograph of it that emphasizes such things as its shape and leaf types. I don't try to be creative; I just try to make the flower as clear as possible for identification purposes. Then I look for additional, more creative ways to photograph the flower if the conditions are right. Sometimes, I just take the identification photo if, for example, the light isn't conducive to creative photography.

Lady fern, Brunswick, Maine

Waterfall, Eastern Tennessee

Making a Difference

Nature photography has a rich heritage of photographers using their images to make a difference in the world. Right after the Civil War, William Henry Jackson explored the American West with his photography. His photographs of the Yellowstone area in 1869 strongly influenced the establishment of this first national park in 1872. In the twentieth century, photographers Ansel Adams and Philip Hyde were also great advocates for the national parks and other environmental issues. Today, photographers like Jack Dykinga and Ian Shive work to make a difference with their images.

Wonderful things abound in the natural world but are threatened by people and politicians whose values are misplaced. You, too, can make a difference in your own area. You have many opportunities for doing this, and it all starts when you share any of your photographs with others. If you visit a spectacular natural location, put up prints of scenes you have captured on your home and business walls. That can make a big difference in both enhancing your home and business environments, as well as helping viewers think about the beauty of our world. Photographing and sharing local nature can open the eyes of people who might not have noticed before they saw your images.

There are many opportunities to do more, if you are so inclined. Photographing local parks and putting on photo shows can be beneficial to both you and the parks. Capturing unique moments in areas threatened by thoughtless development and offering to create a digital slide show for community organizations can help others understand the importance of nature in your community. Presenting slide shows about the natural history of your region can be a great way to connect with your local schools and get young people more interested in the natural world, too.

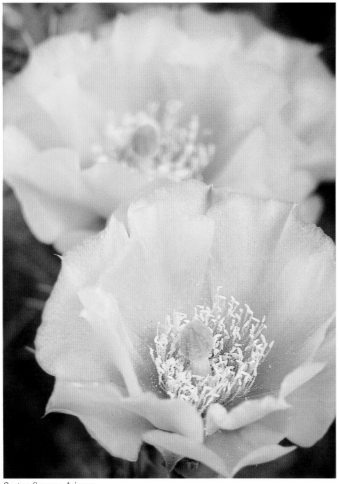
Cactus flowers, Arizona

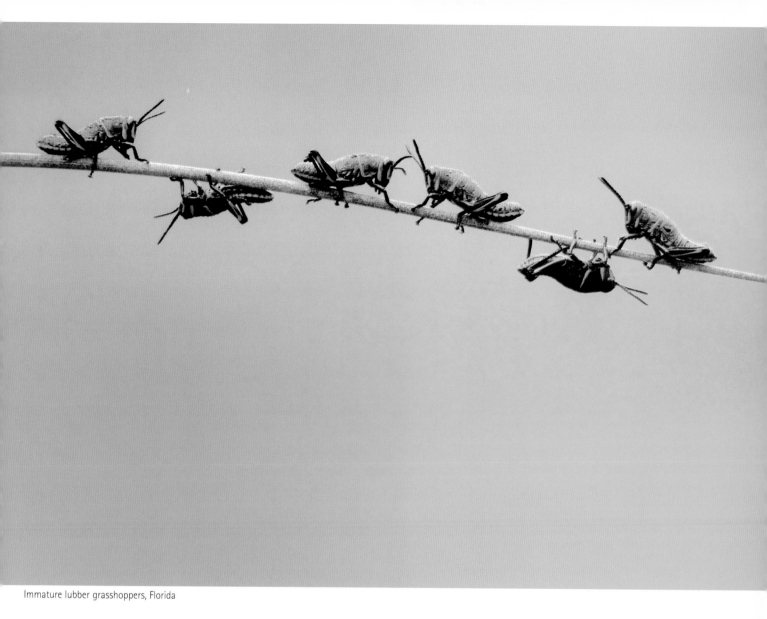

Immature lubber grasshoppers, Florida

Have Fun

Nature photography is fun. At least it should be. After all, it is a great excuse to get outside and enjoy flowers, landscapes, wildlife, sunrises, sunsets, and everything else that makes up our natural world. Photography has both its technological and artistic elements, but that technology can have a downside if it distracts you from having fun with nature photography.

I am not talking about the photographer who loves technology for its own sake. That person has fun discussing megapixels of resolution of his or her latest camera, and if that offers an enjoyable way of passing time, then I'm all for it. What

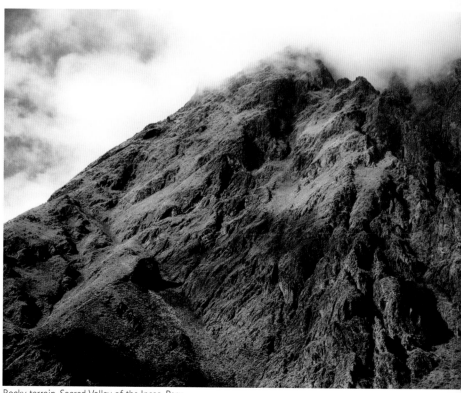

Rocky terrain, Sacred Valley of the Incas, Peru

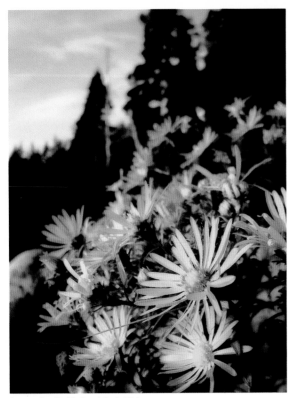

Asters, Acadia National Park, Maine

I am talking about is the photographer who is intimidated by all the shoulds, musts, and oughts that they encounter in photo magazines, ads for camera gear, photo books, and experienced photographers, whether they are well-known pros or local photo enthusiasts.

As soon as you start worrying more about the right f/stop than the subject, you have a potential problem. It can keep you from enjoying the whole process. I know of avid amateur photographers who gave it all up because they didn't think they were "good enough" or that they "knew enough." That is sad.

As I hope you have seen from this chapter, there are many reasons for getting out and photographing nature. It is true that as you learn more about your camera and photography, you can find more satisfaction in capturing the images you really want. Yet, at any level, you can find magic in photographing nature. Frankly, any reason that works for you, works for me.

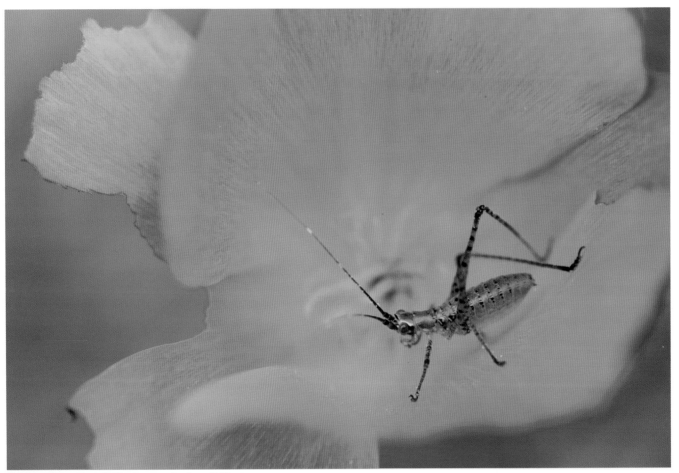

Bush katydid nymph on California poppy, Southern California

An Explanation

In each chapter of this book, you will find a small addition called Connections. I believe it is important to connect with nature beyond simply seeing it as a subject matter. It is easy to sometimes forget the natural part of nature photography amidst the technology and techniques of photography itself. Understanding a bit about the nature you photograph can make your photography better and more satisfying.

One of the problems of modern biology instruction is an overemphasis on details that few of us can relate to. The nature that we all photograph is very much something for everyone to connect with. Biologists are too often interested in reducing life to a gene and a cell, making the science of life not very exciting (even though life is what we are all about).

Nature photography is about celebrating life as we experience it in the real world. A flower may be made up of high-tech genetics and biochemistry, but none of that gives the average person much of a feeling for it's beauty, nor does it show the flower as part of an ecosystem that includes other plants, wildlife, microclimates, and more. Nature photography lets you share the magic of nature as you see it, a magic that can be lost when it is reduced to a chemical formula.

Photography can open people's eyes to this wonder of life. Ecology is not a dry, academic topic, but a way of seeing the diversity and interconnectedness of the world. Being aware of such connections can point you in new directions for your picture taking and even make it more fun. So look for the Connections in each chapter and the connections of nature to your photography.

Cream cup flower, Paso Robles, California

Connections

23

Gear
2

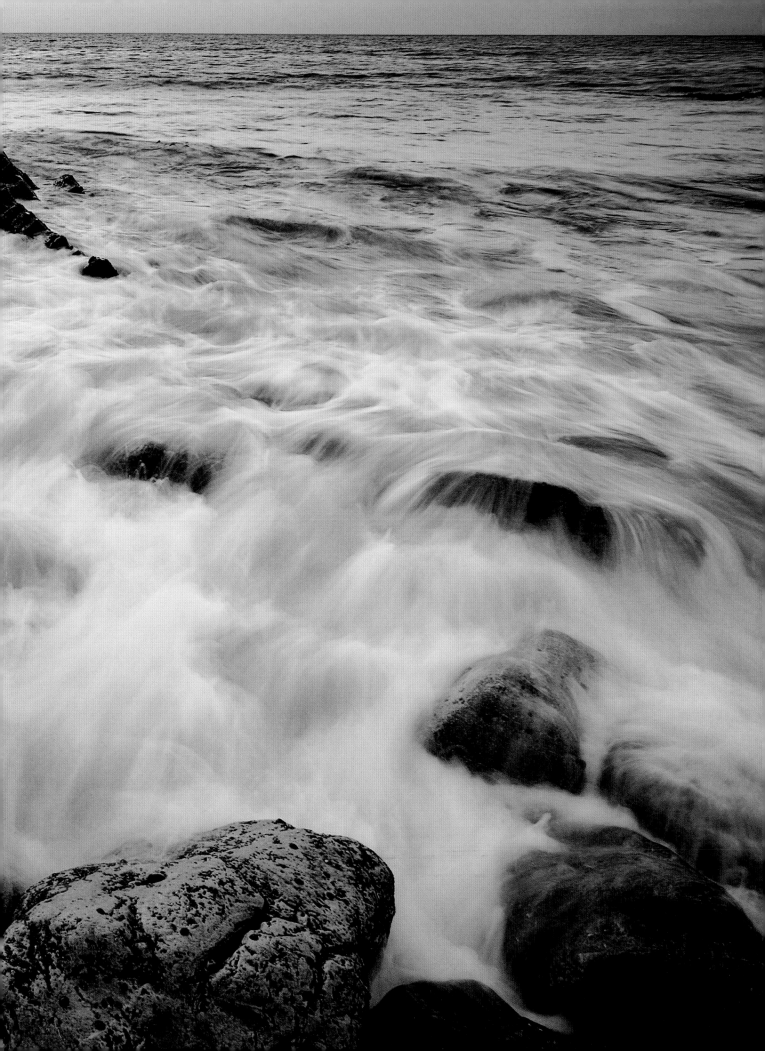

Gear is important, of course, because without a camera, lens, and memory card, you cannot take good digital pictures of nature. But sometimes this is overemphasized by otherwise well-meaning photographers. Deliberations about gear are given too much significance, especially in the frenetic Internet discussions about what this latest camera or lens can do or not do for you. Debating whether you shoot Canon, Nikon, or some other brand is not really relevant to better nature photography. And a lot of the "gear head" websites are more misleading than helpful. To be honest, camera gear is superb today and it really is hard to get bad pictures just because you are not using the "best" model of camera or lens.

Frankly, you could skip this chapter and go right into the techniques of nature photography offered throughout this book and you would be fine. Good nature photography is not about buying the right brand of equipment or even some arbitrarily finest gear because others use it. It is how you see nature and use your equipment, whatever it is, to capture your view of the natural world that is most important.

Overleaf: Sunset on rocky coast
near Los Angeles, California

Choosing a Camera

Cameras come in many different types and styles that can fit the needs of anyone and any type of photography. When looking for a camera specifically for nature photography, you should fit your specific needs to the features available on a camera.

However, since we all know photography is both art and technology, gear is important. No matter how great a time you have in a natural setting, you can't bring some of that magic into a photograph without the appropriate gear for the type of photography you want to do. I do want you to understand how to best match gear to your needs in nature photography and to help you make informed and effective choices to get the best gear possible for you.

Keeping that in mind, photography equipment is a very personal thing. What works well for one photographer often does not work as well for another. You will find equipment specific to a particular type of nature photography discussed throughout this book. This chapter will offer you an overview of gear and how it relates to your specific needs.

One problem today is the rapid pace of technology for the digital photography industry. For a while, it seemed that as soon as you bought digital gear, it would be outdated the next day. You couldn't keep up. This was especially true with the megapixel race. That has changed today. You can buy digital cameras and associated gear that will serve you well for a long time. Unless you get caught up in technology lust, you don't have to buy every latest and greatest piece of equipment as soon as it reaches the market.

The whole point of this is that I want you to enjoy taking pictures and finding your own way in nature photography. Don't be discouraged or intimidated by photographers who tell you that you "must" use this or that gear or that you "must" photograph in a certain way. Find what works for you, then get outside, and start taking pictures!

First, you need to know a little about camera types and how they relate to nature photography. Second, you need to look at what types of nature photography are important to you and how they relate to camera features, plus any other features you may like. Third, you need a camera that you enjoy carrying into the field and that won't weigh you down so much that you have less fun in nature. Finally, you need to find a camera that fits your personality. The latter is so important and often missed by photographers who feel they have to have some specific model that someone else is using.

Some people try to make picking a camera a technical, objective process, and if you are the technical, objective type of person, that may work for you. However, camera selection is too personal and subjective for this approach to work for most people. I can tell you from long experience with photographers and camera equipment that if you don't like your camera, no matter how great the features, no matter how much it fits arbitrary "standards," no matter if it got a top rating from *Consumer Reports*, you won't use it as much as a camera that you truly enjoy holding.

Camera Types

Camera design has a long history, and so we have a variety of camera types to choose from. The type of camera influences how you can use it, what lenses work with it, what other accessories you can use with it, the types of subjects that are most easily shot with it, and more. It can be frustrating if you are attempting a certain type of nature photography because you were inspired by a pro's work, but the pro is using a different type of camera and your gear is not made to do that type of photography.

Nikon DSLR

Digital Single-lens Reflex Cameras (DSLRs)

The DSLR is, without question, the most versatile nature photography camera. Such cameras use a single lens for both viewing and the actual picture taking, making telephoto and close-up photography easy and convenient. A moving mirror is used to send light from the lens directly to the viewfinder or sensor.

Lenses on a DSLR are interchangeable, so you gain a whole range of possible focal lengths, allowing you everything from wide-angles for deep perspective landscapes to macro lenses for detailed close-ups to super telephotos for wild-bird photography. You have complete control over the image, from exposure to focus. DSLRs contain a physically larger sensor than advanced digital zoom cameras, regardless of the megapixels. This results in higher quality colors and less noise. DSLRs range from low-priced models designed for average amateur use to high-priced models built for the demands of professional work. While made to handle bad weather and tough conditions, the pro models can also be big and heavy. For this reason, many pros will often use in-between models because they are easier to wield in the field.

Mirrorless cameras like the Sony model (above and below) are becoming more popular as major manufacturers bring out cameras of this type.

Mirrorless Interchangeable Lens Cameras

Some people confuse DSLRs with digital cameras that have an LCD in their viewfinders and also have interchangeable lenses; however, these are not reflex cameras as there is no mirror to change the way light goes through the camera. These compact interchangeable lens cameras are often called mirrorless interchangeable lens cameras because they have no mirror, and therefore, no optical viewfinder like a DSLR. They are definitely a viable type of camera for nature photography because their bodies and lenses can be made much smaller and more portable than a DSLR, even if they have the same sensor size as a traditional DSLR. All of the advantages of interchangeable lenses apply to these cameras as well. And their image quality rivals that of DSLRs. However, the lack of an optical viewfinder takes getting used to for some photographers, yet what you see is closer to what the camera is actually capturing in a photo because you are looking at what the sensor is seeing through the lens.

Sony point-and-shoot

Point-and-Shoots

A true point-and-shoot camera is a small, compact camera with a non-interchangeable lens (usually zoom) that is designed to only point and capture a photograph. It is mostly automatic, from focus to exposure. These models are relatively inexpensive. They are limited in what they can do for nature photographs. Smartphone cameras are essentially point-and-shoots and are also limited for nature photography.

A primary advantage of advanced zoom cameras is the flexibility to change from wide-angle to long telephoto focal lengths in an instant, allowing you to capitalize on whatever shooting circumstances may immediately present themselves.

Advanced Zoom Cameras

These cameras are often lumped with point-and-shoots, but that is not what they are. This type offers complete control over the image, from choice of f/stop and shutter speed to white balance to manual focus. The lens is built into the camera, and cannot be changed, but there is usually a focal-length range available in different models.

Since they are small and usually have lenses with wide to telephoto capabilities, advanced zooms can be ideal travel or hiking cameras. All of these cameras offer a great deal of nature photography capability in a small, complete package with similar features as a DSLR, but at a smaller cost. Their main disadvantages are lack of interchangeable lenses and sensors that are smaller in physical size than those found in DSLRs.

Live View and Tilting LCDs

Live View is a very important feature for nature photographers. It displays on the LCD exactly what the sensor sees. Combine that with a rotating or swiveling LCD, and you gain terrific capabilities for using a variable-angle "viewfinder" (the LCD). Live View allows you to interpret how the camera is seeing the subject, not simply how you sight on a subject with an optical viewfinder. You can enlarge the Live View on most cameras to get extremely accurate manual focusing, plus there is no mirror bounce to cause unsharp photos because the mirror is locked up for Live View. Live View is the only option for mirrorless interchangeable lens cameras. Live View can take some practice to use well in bright light, though it can be well worth it. Hoods and magnifiers can make it easier to use in bright conditions.

Sensor Size

Digital camera sensors vary considerably in size. Physical size does affect image quality, regardless of the number of megapixels. As a sensor increases in dimensions, the pixels can be bigger. Larger pixels record more light, resulting in improved colors, increased tonal range, and reduced noise. It is true, however, that as technology improves, manufacturers are making better sensors that are smaller.

DSLR cameras use three main sensor formats, or sizes. From largest to smallest, these are: full-frame 35mm, APS-C, and Four Thirds (which is the same format and size as Micro Four Thirds). Many discussions about sensor size end up being about arbitrary differences in image-quality, but sensor size is really about format, which has the same issues as film formats used to have. Sensor size is not about megapixels, which will be covered later.

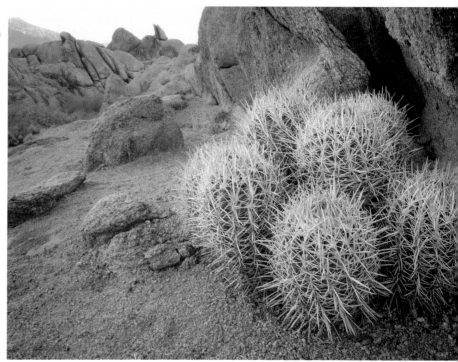

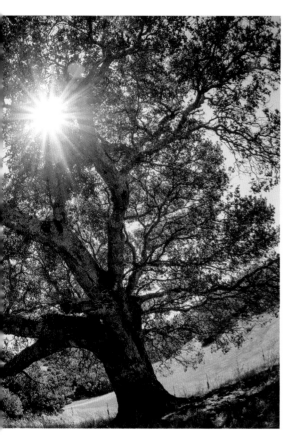

Wide-Angle: Standard wide-angle lenses typically cover a range of focal lengths between Superwide and Moderate. However, the widest focal lengths in this range offer a strong wide-angle perspective and a great deal of depth of field, but don't draw as much attention to themselves as the Superwide range. The end of this range represents moderate wide-angles and is less used in nature photography, though it is certainly available on many zoom lenses. It just does not have a very strong effect. Wide-angle lenses are great for landscapes, for perspective effects, for places where you have limited movement, and for getting more depth of field. This would be approximately 24-35mm for full-frame, 16-24mm for APS-C, and 12-18mm for Four Thirds.

Moderate (or Normal): This category includes focal lengths that photographers have typically referred to as standard and used as their camera's "normal" lens. Its range has been so common that some pros avoid it because the look is so pervasive. In some ways, these focal lengths are "invisible" in the sense that they have no distinctive look and actually mimic the way we see with our eyes. Some photographers, especially the pure documentary photographers, have deliberately chosen lenses in this range for that reason. This range would be approximately 45-65mm for full-frame, 30-42mm for APS-C, and 22-32mm for Four Thirds.

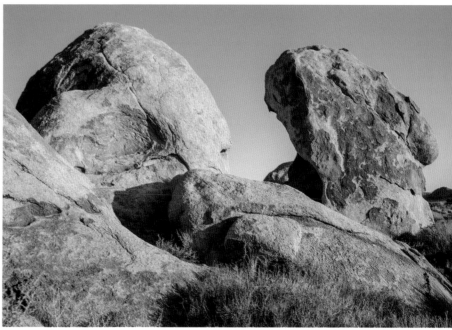

Alabama Hills, California

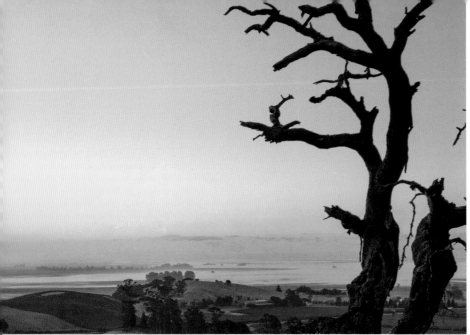

Sunrise, Sonoma County, California

Short Telephoto: The short telephoto is called that because the focal lengths are relatively short compared to most telephotos. This category, falling between Moderate (Normal) and Moderate Telephoto, offers a slight magnification but does not have strong telephoto effects (such as strong perspective compression). The short telephoto focal lengths are common in macro lenses offering a bit of magnification so that you can give a little space between your lens and subject. This range, approximately 80-105mm for full-frame, 55-70mm for APS-C, and 40-52mm for Four Thirds, is a very popular range for photographers who do formal portraits.

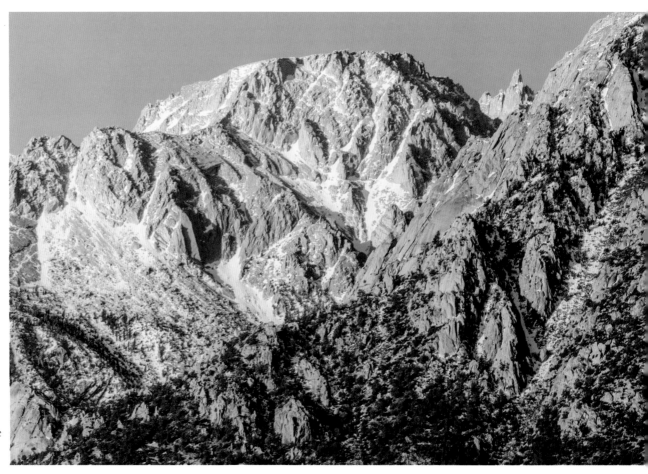

Sierra Nevada Mountains, Lone Pine, California

Moderate Telephoto: Moderate telephotos cover a range of focal lengths that definitely magnify subjects yet the magnification isn't so strong as to make the lenses difficult to handhold. These focal lengths offer a great set of choices for using telephotos on a landscape or for getting detailed shots of subjects that won't let you get close, such as butterflies. These focal lengths mark the shortest usually needed for wildlife photography. Moderate telephoto lenses are relatively affordable and easy to carry, and cover the approximate range of 150-300mm for full-frame, 100-200mm for APS-C, and 75-150mm for Four Thirds.

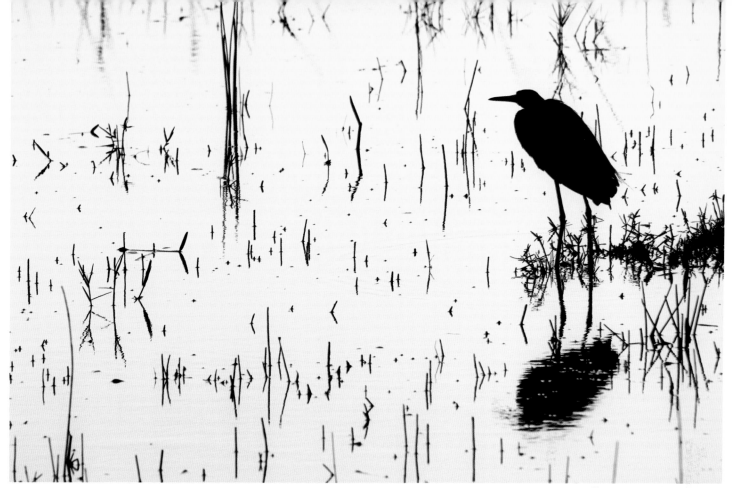

Heron at sunset, Loxahatchee
National Wildlife Refuge, Florida

Long Telephoto: Long telephoto lenses become prime lenses for wildlife, offering 8–10x magnification of the subject. Some photographers also use them for their extreme perspective effects on landscapes (flatten perspective, isolate details in a distant scene). They can be large and expensive. This lens type includes approximately 400-500mm for full-frame, 250-350mm for APS-C, and 200-250mm for Four Thirds.

Extreme Telephoto: Extreme telephoto focal length lenses reach a range that most nature photographers rarely use. The exception is the wildlife specialist. Wildlife photography, especially of small birds and wary animals in big spaces, can demand magnification up to 12x of the subject, but these lenses can be very large and quite expensive. Using tele-extenders can help reach this range of magnification at a lower cost as sensor size gets smaller. This would be approximately 600mm and above for full-frame, 400mm and above for APS-C, and 300mm and above for Four Thirds.

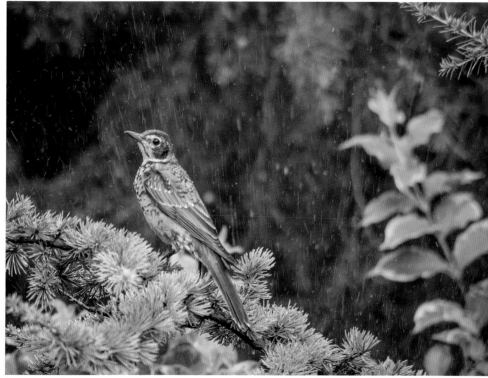

Robin in rain, Southern Illinois

Additional Lens Factors

Besides focal length, you need to consider four things when thinking about buying a lens: speed, type, size, and construction. These affect the usability, quality, and price of the lens.

Speed

The speed of a lens refers to the widest lens opening or f/stop that the lens can offer. Lenses are always described with this speed, e.g., a 100mm f/2.8 lens or a 70-200mm f/4 zoom. The f/2.8 and f/4 are the widest lens openings for those lenses. The faster the lens, the more light can potentially come through it. Fast lenses compared to slower lenses offer a number of opportunities: you can photograph more easily in low light levels, you are able to use faster shutter speeds and lower ISO settings, autofocusing becomes faster for the camera, and the viewfinder in a DSLR will be brighter. In zoom lenses, the speed of the lens may change with focal length (called variable aperture), such as a 28-80mm f/4–5.6 zoom. That means the lens is f/4 at 28mm but loses a stop of speed at 80mm (f/5.6).

However, faster lenses are also more expensive, sometimes considerably more, even with the same build-quality. This is a very important factor to consider. In fact, if two high-quality lenses are compared, the less expensive, slower lens may offer better results than the higher priced, fast lens because it is more difficult for lens designers to maintain quality as the maximum aperture becomes wider. The higher price of the fast lens is due to the need for added glass elements, larger optics, and more challenging lens designs. That said, the lowest priced, variable-aperture zoom lenses will generally not match the quality of higher-priced zooms or single-focal length lenses, though modern computer designs and manufacturing technologies allow these lenses to be remarkably good for the price.

In addition, faster lenses are also much heavier. Many photographers have welcomed the advances in quality at high ISO settings because that allows them to use slower lenses in the field.

The speed of the lens is not a simple choice. It used to be if you were shooting wildlife, you wanted to get every bit of speed possible to ensure you could use the highest shutter speeds at all times. That is not nearly as true today because you can now record better quality images than ever before while using high ISO settings on most DSLRs. If you are shooting landscapes, speed may be much less important than shooting other genres. Slow lenses are smaller and less expensive than fast ones, and this does include the budget lenses now manufactured by many companies.

This lens covers a focal length range from 28 to 300mm. Zoom lenses often have maximum apertures that vary as the focal length is changed, and most are considerably "slower" than prime lenses of similar focal lengths. Consider whether or not the lens offers an image stabilization (IS) or vibration reduction (VR) feature.

Type

Should you go with a zoom lens or a prime (single-focal length) lens? Zooms are definitely the most popular lenses today, and for good reason. They offer a great range of focal lengths in a single package, giving the nature photographer more options without having to carry more lenses (or having to spend more money). Convenience and portability are important and valuable benefits of a zoom lens, and image quality can match that of single-focal length lenses.

So why consider single-focal length lenses? Speed, size, and cost—single focal lengths are almost always available in speeds that are much faster than zooms, they are usually physically smaller lenses at the same speed, and they cost less. Zooms can be very slow, or if they are fast they are usually expensive. In addition, a zoom lens can be much bulkier and heavier than a single-focal length lens (though it will be much lighter than a collection of prime lenses), and it will often have a larger front lens element that requires very large filters. Finally, images recorded using wide-angle zooms, and especially wide-to-telephoto extreme zooms, are difficult to produce without some barrel distortion (a bowing of straight lines along the edges of the image). In many cases, this latter condition is not a serious problem in nature photography since straight lines are not common (except for water horizons) and the distortion can be corrected in programs like Photoshop.

Size

As a nature photographer, you need to consider size when you are trekking into the wilds. Lenses vary considerably in size due to a number of factors, some of which have already been discussed, such as speed. Sometimes you need to make compromises in order to gain a lighter lens for field use. Lenses get lighter as their speed decreases, the zoom range is smaller (or the lens is a single-focal length), the lens has special construction (such as diffractive optics that reduce the size of lens elements), or the lens body is polycarbonate rather than metal construction. Less expensive lenses will usually have polycarbonate bodies, which can still offer a good quality lens.

Construction

How a lens is designed and made will influence cost, quality, size, and more. Elements used in the construction of a lens have a big effect, but the good news is that modern manufacturing techniques have allowed some of the highest quality lens elements to be used in very affordable lenses.

The two main lens elements affecting lens construction are aspheric elements and low dispersion glass. Aspheric elements are optics with a unique design—they have a changing curve to the lens so that the surface is no longer a standard spherical lens. This allows lens designers to more easily correct certain lens defects (such as spherical aberrations) that can be a problem, especially in wide-angle zooms. Aspheric elements were once a very expensive optic to produce, but this is no longer true, so are now included in a number of good-quality, very affordable wide-angle and wide-to-telephoto zooms.

Low dispersion glass (also called extra low dispersion, ED, super low dispersion, and other variations) is another high-quality addition to a lens that used to be quite expensive. This glass is optically very pure and allows lens designers to minimize problems like chromatic aberration. This will make a lens give a crisp, brilliant look to the images. You'll also see the term apochromatic or APO to describe lenses that are highly corrected for such aberrations (and usually include low dispersion glass of some sort).

How a lens is made affects its weight, durability, and price. Low-priced lenses can be optically fine, but are not built to the physical standards of high-priced lenses, so they may not hold up as well under tough conditions. High-priced "pro" lenses often have extra gaskets and seals to allow them to function in rain and other severe conditions. If your nature photography never stresses your equipment, lower priced lenses may be fine. On the other hand, if you are going into rough environmental conditions, the pro-type lenses may be a necessity.

Internal focusing is a special construction that has become common even on budget lenses. Internal focusing allows a lens to focus without changing its length, and also it can focus faster. In addition, internal focusing keeps the front of the lens from turning, which is a huge advantage when using polarizing or graduated neutral density filters.

Well-constructed lenses with highly-engineered glass elements that can weather adverse conditions are usually pretty expensive. Over time, many of these technologies have filtered down into more affordable lenses.

Avocet, Southern California

Another innovation in lens design worth considering is lens stabilization. This first appeared in a Canon 70-300mm IS (Image Stabilization) lens in the mid 1990s. Now stabilization technology is available in quite a range of lenses from all manufacturers. These all work similarly by moving lens elements inside the lens to counteract camera and lens movement during the exposure. Olympus and Sony offer another type of stabilization—in the camera instead of in the lens—where the sensor moves to compensate for movement so you do not need an image-stabilized lens. The result of any of these image-stabilizing technologies is that slower shutter speeds can be used and sharpness maintained even when the camera cannot be locked to a heavy tripod. This is a great tool for nature photographers who need to handhold a lens or want to use a light tripod.

Choosing a Tripod and Head

The tripod is an extremely important accessory for the nature photographer. It is true that a tripod is an extra item that must be carried along, and that is not always easy to do. In addition, it may seem like an added cost for a not-very-exciting accessory. Many photographers decide not to buy one, but that can be a real problem in nature photography for several reasons.

Much of nature photography is shot in low light conditions. With a tripod, you can shoot these conditions and have free choice of f/stops because you can use slow shutter speeds.

Ultimate sharpness of a lens is achieved with a tripod. I have seen photos from photographers using the most expensive lenses that don't come close to matching images from a budget lens because the photographers with the expensive lenses didn't use a tripod. A tripod will make images taken with an average lens look great, and those taken with a great lens look like it is more than worth the price.

Camera movement destroys image brilliance. Sometimes photographers not using a tripod will say their photos are sharp, and in small prints, they look sharp. However, tiny movement of the camera during exposure can dull minute highlights in a photograph that affect the brilliance or crispness of an image.

Composition is better assessed with a camera on a tripod. You can easily judge your compositional choices and better see what is happening within the frame. Of course, you don't need a tripod all the time, nor is it possible to always use one. If you can use fast shutter speeds or image stabilization, you

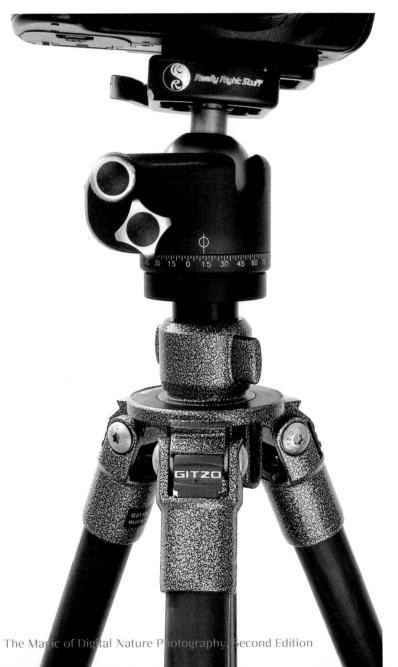

can shoot without a tripod. However, in nature photography, a tripod is a necessity for many photographic situations. Getting the right tripod can make a big difference in how often you use it. If the tripod is hard to use, too heavy, or hard to carry, you won't use it.

Most high-quality tripods come either without a head or with a removable head. This is important because using a tripod head is a personal decision and affects how certain types of photography can be done. There are two head types commonly available (plus some special heads designed to facilitate certain lenses and subject matter).

Ball heads are the most commonly used among nature photographers. They have one knob or lever to loosen the head. The camera can then be moved in all directions as the ball part of the head rotates in its socket. This freedom of movement makes it very easy to set and level quickly even if the tripod is positioned on uneven ground. These heads come in a variety of ball sizes, but small ones really aren't very practical, even if they are less expensive.

The problem that some folks have with a ball head is that there is only one control to lock the head. If you aren't careful, a camera/lens combination can drop unexpectedly against the tripod when you loosen the control because you weren't ready for it to move in that direction. The second type of head, pan-and-tilt, lets you limit the movement of the camera to certain planes, one at a time, so that the camera is less likely to dump. Some people also find this kind of head easier to level. However, the pan-and-tilt head often has large handles that can get in the way. In addition, this type is usually physically larger and is much slower to use. Both heads utlimately do the job, however, so it really comes down to personal preference.

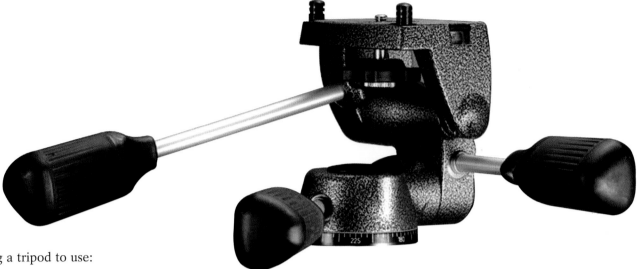

In choosing a tripod to use:

• Think about your tripod and head as investments in your photography, just as you would for a high-quality lens or a good flash unit. A cheap, non-brand tripod can be worse than no tripod at all and will negate improvements you might otherwise expect from buying that high-quality lens you've been saving for.

• Buy from a local camera store if you can so you are able do hands-on research with several models, checking out features, dimensions, and ease of use.

• Set up the tripod to be sure it is the height you need without the center column. Only use the center column if you have to, as it is not as stable as the tripod itself.

• As you set up the tripod, pay attention to how easily the leg-locks work for you. Are they intuitive to use and can you adjust them quickly?

• Once the tripod is set to its maximum height, be sure the legs are locked, and then lean on it a bit. A good tripod will easily handle the weight without moving much, if it all.

• If you can afford it, get a carbon-fiber tripod. Lightweight and very sturdy, carbon-fiber tripods are easiest to carry into the field and worth the cost if you already invest a significant amount of your time shooting nature or landscape shots.

• If you don't have the money for a carbon-fiber model, look for a metal tripod made from lightweight metal alloys (Aluminum, Magnesium, and/or Titanium).

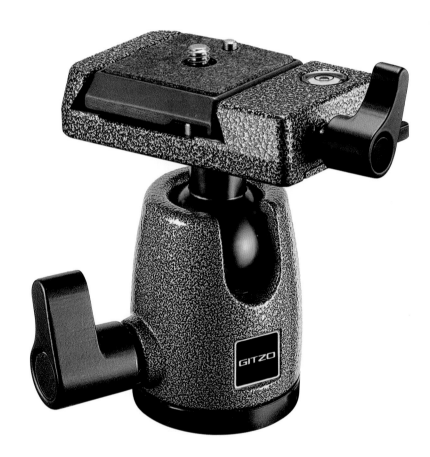

• If you need a small tripod to pack in a suitcase for travel, check its collapsed size. You may have to compromise on the full height needed. Again, be wary of inexpensive, multisegment-leg tripods (avoid more than four leg sections), as these are often so unstable that they can spoil image sharpness rather than enhance it.

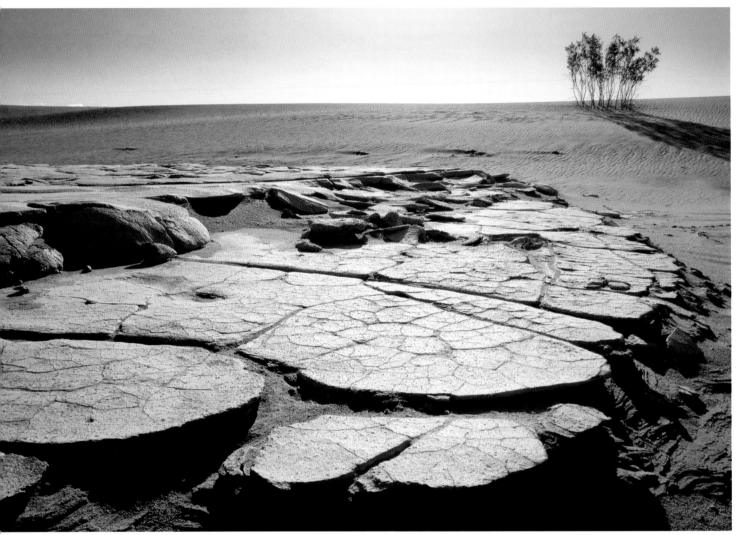

Don't shoot all pictures on your tripod from the same height. Adjust the legs and/or center column to alter the camera's height to vary the perspectives for your landscape photos. Death Valley National Park, California

A special head for big telephotos used in wildlife photography is the gimbaled head. These are not generally available in camera stores and may have to be ordered directly from the manufacturers (which are small companies). The gimbaled head balances a big lens quite nicely and allows you to keep the head unlocked so you can follow a moving bird, for example. This head can be expensive, but if you really need it, you'll find the price is worth it.

Opposite, top to bottom:

Santa Monica Mountains, California; Paso Robles, California; godwits at sunset, Southern California

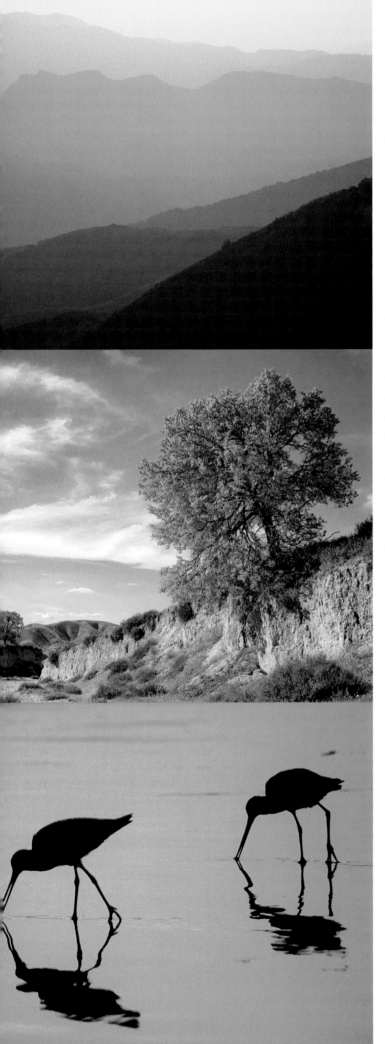

Binoculars

Binoculars are a great bit of gear that won't automatically help you with photography (though they can help you locate and identify subjects), but can greatly increase your enjoyment of nature. I like having a compact, lightweight pair of binoculars in my camera bag for a number of reasons, from watching wildlife to spotting butterflies.

Binoculars come in a huge range of sizes, prices, and power. For the photographer, I recommend the moderately priced compact type. Cheap binoculars are rarely worth the price. They typically are bigger and heavier, plus their optics can strain your eyes. You might not know why, but you will find you don't enjoy using them.

With increased power, binoculars become harder to hold. The view just bounces around too much to be useful. (Image-stabilizing binoculars do work well, though they are also pricey.) Binoculars of 6, 7, or 8 power offer good magnification that can still be easily handheld, plus they can be small. Binoculars are described with two numbers, such as 6x28 or 7x35. The first number is the magnification power, while the second is the size of the front or objective lens. The larger the objective lens, the better the binoculars work in low light, but that means they are bigger, too.

Binoculars come in the traditional zigzag shape of the porro prism design or the straight tube roof prism design. The roof design is more expensive because the optical path is more complicated (the light does not go straight through the tube), but it is much more compact. Porro designs give you more for your money, but might not be appropriate to your needs.

Great binoculars are available from all the camera manufacturers as well as binocular manufacturers. It is important to pick up a pair and look through them before buying. You need to see how easily the controls work, how clear and crisp the view is (look through several models for a comparison), and how comfortable they feel to you. A good pair of binoculars will almost seem invisible, like you are just seeing something magnified with your own eyes. A poor pair of binoculars will make your head ache from your eyes trying to compensate for optical problems.

Connections

Tech Details
3

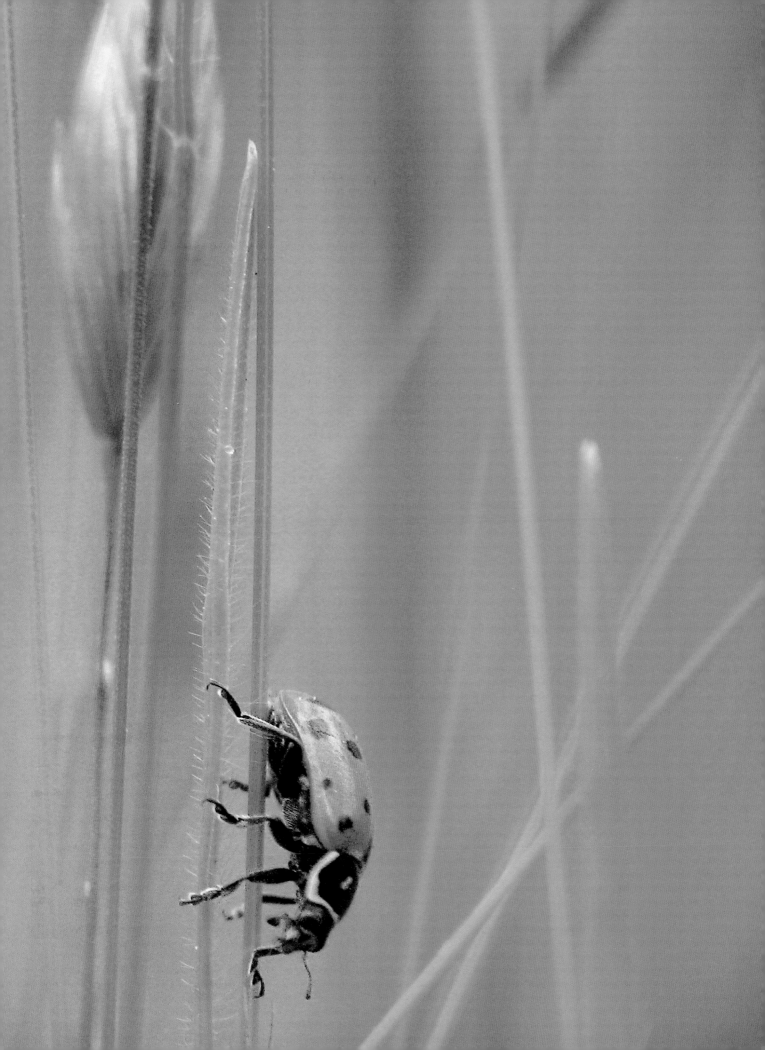

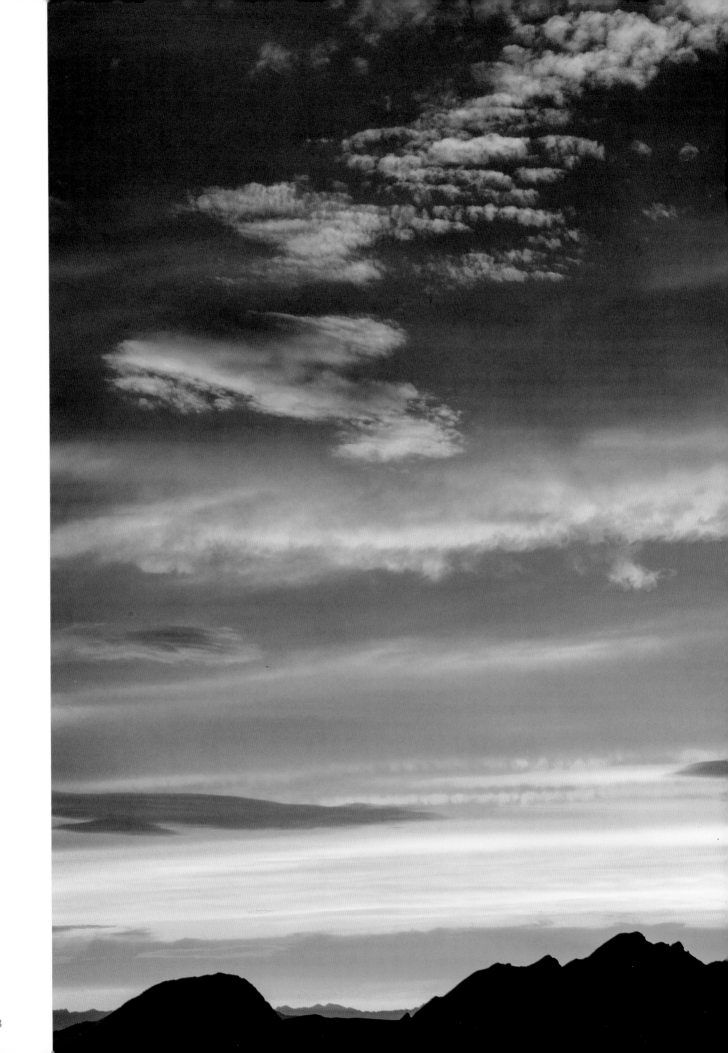

Photography has long been an interesting blend of art and technology. Some photographers mainly emphasize the artistic side of photography, while others are more fascinated with the technical side. Good nature photography demands both. You don't have to be a scientist or an engineer, and don't let anyone intimidate you into thinking so. However, mastering at least some of the technology will help you control the photographic process so that you are more likely to get the results you really want.

Ansel Adams used to compare photography to playing the piano. If one masters the scales and other technical parts of piano playing, but has no feel for the music, then no art will appear, though people may be impressed with your skill. If one has a great feel for the music but no mastery over the keyboard, no art will appear either. The master combines both, blending technical virtuosity with sensitivity to the music in order to create something of real beauty.

This chapter will offer an overview of key technical aspects of nature photography. Some you may know, some you may not know. You can pick and choose those that supplement your skill level. Or you can just skim through this chapter to figure out what is most important to you right now in your photography.

Good Exposure Is Important

Exposure meters and cameras have reached a state of amazing capabilities. In average situations, you can be sure you will get a good exposure. Unfortunately, nature photography sometimes throws us challenges that are not average. If you know how an exposure meter works and how to deal with its interpretations of light, you will be able to quickly deal with any lighting situation.

Exposure affects colors, tones, noise, and details. The photo at left below is properly exposed. Underexposure causes dark areas to look murky and lose detail (middle), while overexposure washes out detail in bright areas (right). Wild azaleas, Muir Woods National Monument, California

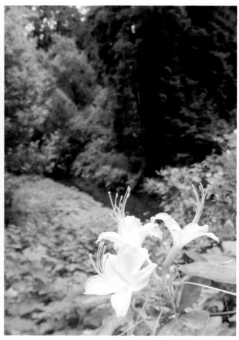

Overleaf: Ladybug, Bakersfield, California

Left: Muddy Mountains, Mojave Desert, California

Obsidian dome near Mammoth Lakes, California

Exposure is based on three variables: f/stop, shutter speed, and digital sensitivity (ISO setting). All three will be covered shortly. But first, it helps to understand what exposure is all about. Good exposure makes bright things bright. Digital cameras struggle with dark areas, so if bright areas are exposed too darkly, dark areas will not have the proper exposure. That can adversely affect color, contrast, and noise. However, bright areas must not be overexposed, either, or they will lose color and contrast.

Another exposure issue to consider has come with the growing sophistication of the digital darkroom that has often led to an attitude of "you can always fix it in the computer." In addition, many digital photographers have been misled into believing that using the RAW file format means you don't have to worry as much about exposure. Finally, because digital files can have a problem with overexposure, many photographers overcompensate by consistently giving too little exposure.

Good exposure results in tonalities and colors that make your subject look its best for the light. Strong under- and overexposure problems are obvious: too little exposure makes for dark tones with little color and lost detail, while too much exposure results in too bright shadows and washed out highlights. But even slight under- or overexposure can cause problems.

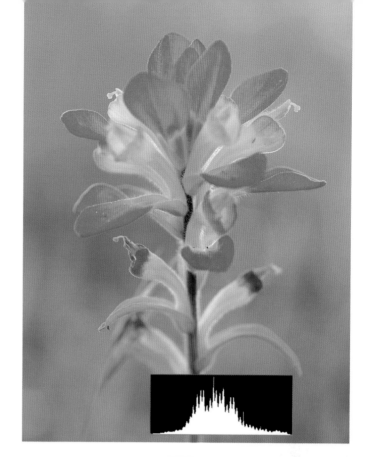

Exposing Properly

To understand exposure, it helps to know what an exposure meter does. It looks at the brightness of things in a scene and tells the camera to choose an exposure that will make elements in the photography appear middle gray. It does not know if those elements are supposed to be middle gray or not; the subject could be pure white snow or a dark grove of evergreens; the meter will still try to make them middle gray. That reading would underexpose the snow scene and overexpose the evergreen scene.

The Histogram

The histogram is a great tool for achieving the best exposure of an image when using digital cameras. A histogram is a graph of the tonalities that your sensor records from the scene. Since it is a graph, it can seem intimidating to some photographers, but it doesn't have to be. You can break it down very quickly into a few key elements, and use that information to help you choose better exposures.

If you understand four important things about a histogram, you can use it to get better digital exposures:

1. The histogram is an accurate interpretation of exposure—It is far more accurate than your LCD monitor.

2. It allows you to monitor dark tones—The left side of the histogram represents shadows and the amount of black in the scene.

3. It allows you to monitor bright tones—The right side represents highlights and the amount of white in the scene.

4. It points to exposure problems—A gap or a cliff at the right side of the histogram indicates exposure that is not totally optimal.

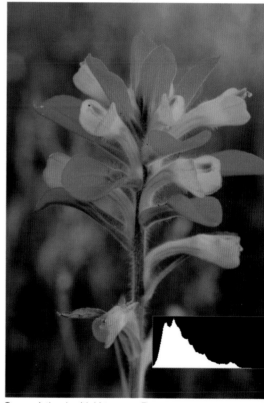

Texas paintbrush with histograms. The upper photo is properly exposed; the lower photo is underexposed and puts important tones and colors too far left in the histogram, leaving a gap on the right.

Keep those things in mind—as you use a histogram, they will become intuitive—so that you can use the histogram in these ways:

• **Watch for clipping**—If the histogram hills stop at a steep cliff at the right side, detail is clipped. This means there are additional tones and colors that could be captured but are not because the detail is "clipped" off; you have reached the end of your sensor's capabilities. When clipping occurs at the right, highlights will be blown out. If those details are important, reduce your exposure to move the histogram left to avoid the clipping.

• **Avoid big gaps on the right side**—Gaps can be as problematic as clipping. There will be a gap in tonal details if your histogram does not slope all the way to right edge of the graph. You are not using the full range of the sensor and this will push colors and tonalities off their optimum exposure range. Increase exposure to lessen the gap.

• **Watch where main tonalities fall**—This is especially important with dark subjects. You do not want all of their tonalities on the left side, even though they are actually dark. You will get better color and less noise if you give "enough" exposure that the bulk of the graph is not pressed tightly to the left. It is better to give additional exposure to a low-light scene so that dark tones are shifted more toward the middle, and then darken with software on the computer, than it is to try making a dark scene lighter.

Aperture

Aperture is a variable opening inside the lens that controls the amount of light coming through. The opening varies in precise steps called f/stops. These are derived from a mathematical relationship of focal length to the size of the opening, which is where the numbers come from.

The numbers can be confusing. Large numbers, such as f/16, are actually small apertures, and are called small f/stops. You "stop down" your lens to get to them. Small numbers, such as f/2.8, represent large apertures and are called wide f/stops. You "open up" the lens to get to them. These numbers are actually fractions, (1/2.8 is bigger than 1/16; though the f/stops aren't typically displayed that way). Any given f/stop allows the same theoretical amount of light through the lens so that f/5.6 on one lens is the same as f/5.6 on another even though the lenses are different in size.

With the exception of some specialty lenses and optics for large format cameras, nearly all lenses have an f/stop range that includes most of the following set of numbers:

f/2, f/2.8, f/4, f/5.6, f/8, f/11, f/16, f/22

Each f/stop affects the light coming through the lens in a strict doubling or halving relationship. For example, if you go from f/2.8 to f/4, you halve the light coming through the lens. If you change f/stops from f/8 to f/5.6, you double the light coming through the lens. If you go from f/4 to f/16, you go through four f/stops and the light drops to 1/16th the original amount. Sometimes other f/numbers show up on the camera; these are usually half or third stops and affect the light accordingly.

In addition, f/stops also affect depth of field. In the f/2 to f/22 list above, depth of field increases as you choose f/stops toward the f/22 end, and it decreases as you move toward f/2.

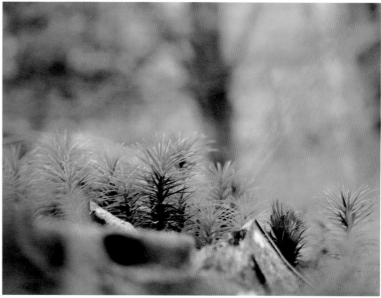

The difference in depth of field comes from the f/stop chosen in each picture of this moss in Vermont. The left-hand photo has a small f/stop (large number); the photo at right has a wide f/stop (low number).

Shutter Speed

Exposure is also changed by selection of shutter speed. Shutter speed affects how long the light is allowed to come through the camera and strike the sensor. It is a fraction, such as 1/125 second, but is often expressed on the camera as a single number, such as 125. Shutter speeds are very direct in the way they affect exposure. 1/125 second is twice the number of 1/250 second, so it lets in light twice as long. Similarly, 1/30 second is half of 1/15 second, so it lets in half the light. Numbers do get rounded, so 1/8 second is used for twice the duration of 1/15.

Shutter speeds have a direct bearing on sharpness. Faster shutter speeds will stop the action in a scene, and slower shutter speeds will blur a moving subject. You need the fastest shutter speeds with fast moving subjects, such as a running animal or flying bird moving across your field of vision. You can actually get away with slower speeds if the animal is moving directly toward or away from the camera.

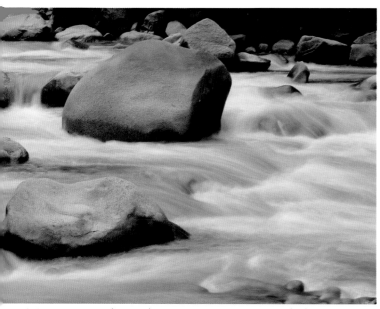

A slow shutter speed (1 second) blurs the Urubamba River in Peru (left), while a faster shutter speed (1/125 second) shows a different amount of detail for the same scene (right).

You also need fast shutter speeds for handholding a camera, as slow speeds will allow camera movement to register during the exposure if you are not using a tripod. Fast shutter speeds are needed with wind-blown trees or flowers, too. Finally, you will often need the highest shutter speeds not merely to stop action, but to allow you to choose a wide lens opening when the light is bright.

Slow shutter speeds balance small lens openings. The lens lets in less light with a narrow aperture, but a slow shutter speed lets the light through to the sensor for an extended period time. In nature photography, slow shutter speeds usually mean you have to use a tripod. If you like blur effects, such as the blending of moving water, or the abstracts of blurred vegetation blowing in the wind, then you need to experiment with slow shutter speeds. No specific guidelines can be given, since the type and speed of movement will change the blur effects with every exposure chosen.

You do need to be careful of shutter speeds the camera is setting if you are shooting on automatic in either program or Aperture Priority autoexposure modes. Many photographers neglect to notice the speed the automatic function sets for the shutter, and the camera may select a shutter speed too slow for the action or for handholding the camera, resulting in images that are not sharp. Here are *minimum* shutter speeds you should keep in mind if you are handholding the camera:

Full-Frame
Wide-angle lenses (35mm and wider) – 1/30 second
Moderate focal lengths (45–65) – 1/125 second
Moderate telephotos (150–300mm) – 1/500 second
Long telephotos (400mm and longer) – 1/1000 second

APS-C
Wide-angle lenses (24mm and wider) – 1/30 second
Moderate focal lengths (30–42mm) – 1/125 second
Moderate telephotos (100–200mm) – 1/500 second
Long telephotos (250mm and longer) – 1/1000 second

Four Thirds
Wide-angle lenses (18mm and wider) – 1/30 second
Moderate focal lengths (22–32mm) – 1/125 second
Moderate telephotos (75–150mm) – 1/250 second
Long telephotos (200mm and longer) – 1/1000 second

Exposure Modes

There are five common exposure modes on many cameras: Full Auto or Program, Shiftable Program, Aperture Priority, Shutter Priority, and Manual exposure. There are also special program modes on many cameras, such as "Close-up" or "Night Flash," but as these change from camera to camera, consult your instruction manual to best know what modes are available with your model.

Full Auto or Program

This is exposure under full control by the camera (often identified on camera mode dials as the green zone). Nothing can be changed. Whatever the camera chooses for f/stop and shutter speed, that's it. This is a good one to use when someone else is using your camera to take a picture of your family, for example, because they can't change any settings. However, this is not the best mode for nature photographers. Generally, you will want to have some say in either the shutter speed used to stop action or the f/stop chosen to affect depth of field.

Shiftable Program (P)

This is the autoexposure mode that lets the camera arbitrarily pick a shutter speed plus f/stop combination, but if you don't like it, you can adjust either shutter speed or f/stop for a single exposure and the camera will follow your lead. Better than Full Auto, Shiftable Program still is limited because you can't set exactly the f/stop or shutter speed you need for each shot.

Aperture Priority (A or Av)

Here, you choose an f/stop that is appropriate to the needs of your photograph or subject, and the camera automatically sets the right shutter speed to match that f/stop. This is probably the most useful autoexposure setting for nature photographers. It allows you to choose an f/stop for depth-of-field and for the optimum shutter speed. No, that's not a misprint. Many sports and wildlife photographers want the fastest shutter speed possible for the conditions. If they use Aperture Priority and choose the widest aperture possible on their lens—the lowest f/stop number—the camera will automatically choose the fastest shutter speed possible for the conditions, even if the light changes.

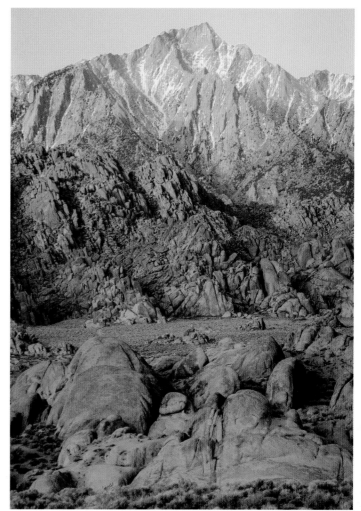

Aperture Priority lets you control how much of the scene you want to be sharp. Alabama Hills, California

Shutter Priority (S or Tv)

With this autoexposure mode, you choose the shutter speed and the camera picks the right f/stop to go with it. When you are in bright light, you can use this to set a fast shutter speed for action, but if the light changes and drops below the combination of this speed and the lens' widest opening, you won't be able to photograph. This setting is very often used to control how action blurs by choosing a specific slow shutter speed.

Manual Exposure (M)

In Manual exposure mode, you can set both the aperture and shutter speed. You can follow the meter's recommendations or do something entirely different. Manual exposure is very useful when shooting in difficult lighting conditions, such as following an animal in one light (that your camera can be set for) that then moves through differently lit backgrounds (which would fool the meter). It is also very important for multiple-image panoramic shooting so each shot is consistent.

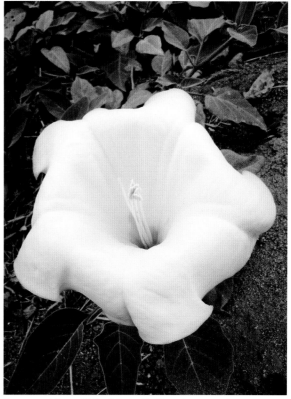

Jimsonweed flower (Datura) shot with Manual exposure to compensate for the whiteness

ISO Settings

ISO is an international standard for film from the International Organization of Standards. (ISO was chosen as a simple letter designation for certain standards, like the speed of film; it is technically not an acronym.) In the digital world, ISO is related to the international film standard of ISO, but there is no international standard for digital ISO because ISO settings are affected by the way the image signal from the sensor is processed (and yes, this happens with RAW files). However, it still has a direct connection to exposure.

A low ISO setting, such as 100, means the camera and sensor are less sensitive to light than a higher ISO setting, such as 400. The numbers relate directly to each other, i.e., ISO 100 is half as sensitive to light as ISO 200, and ISO 400 is four times as sensitive as ISO 100.

An ISO value of 100 or less usually gives the highest quality image results in terms of sharpness, color, tonality, and low grain or noise. But it also means slower shutter speeds or wider lens openings must be used. Higher ISO settings will reduce image quality, though current digital cameras do offer extremely good results with ISO settings of 1600 or even higher, and that is always improving. Cameras are reaching the point that even ISO settings of 400 equal lower settings of just a few years ago, and often have superb image quality. Point-and-shoot cameras will have increased noise at all ISOs compared to larger cameras just because their sensors are so small. Higher ISO choices allow you to shoot at much faster shutter speeds or use smaller lens openings.

Most nature photographers with APS-C or Four Thirds cameras will use ISO settings of 100 (or less if possible on their camera) for general nature photography, while those using full-frame DSLRs often use up to 400 ISO. This is especially true for landscapes. The most recent cameras of all types work well at 400 for general shooting if you feel you need the speed. If you are shooting from a tripod during the day, the low ISO sensitivity will not be a problem. Wildlife photographers, however, often shoot at higher ISO settings so they can use faster shutter speeds to stop animal movement or to deal with slow telephoto lenses.

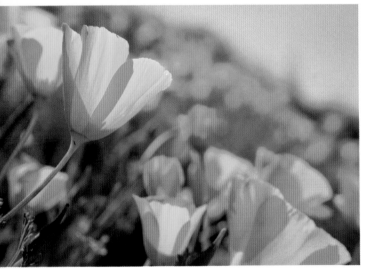

California poppies, Paso Robles, California

RAW versus JPEG

You will hear pros and cons about RAW and JPEG image files. Judgments about image quality are made arbitrarily about these formats, or people erroneously think that RAW is a pro format and JPEG an amateur format.

Let's quickly make a one thing clear: Both formats are perfectly capable of creating pro-quality images and pros use both. This book has images that are from both and you will not be able to tell the difference. It is unfortunate that some photographers give the impression that you must shoot one or the other or your photos will suffer. That is simply not true. There are good reasons for both formats. Their use depends mainly on your needs. We'll look at the advantages and disadvantages of both.

JPEG is a high-quality compression format. At its high-quality settings—which should always be used on a digital camera— image quality can be equal to that of RAW. As long as it is used just as a shooting format and not as a working format in the computer, it works well.

A JPEG is a RAW file that has been smartly processed in an automated way in the camera. Many camera manufacturers have put a great deal of engineering into their cameras' image processing capabilities. It is almost like having a RAW expert inside your camera to get the most from the image as it comes from the sensor. Another JPEG advantage is file size. Because JPEG is compressing data to manageable image file sizes, it needs a fraction of the space on a memory card that RAW files demand. Since large memory cards are relatively inexpensive, a more important factor is that smaller file size also means faster file handling for the camera so that you can usually shoot in longer bursts of continuous shots.

On the other hand, JPEG has a reduced color range (or bit depth) compared to RAW. JPEG has 8-bits of data for each of the three colors (RGB) used to construct a "fully" colored image (therefore 8-bit is sometimes also called 24-bit), while RAW generally deals with 12-bits per color (36-bit). (You will often see RAW referred to as being 16-bit; nearly all digital cameras record images at 12-14 bits, but they put this data into a larger 16-bit file.) This extra data represents an exponential increase in color information, but you won't directly see it, since 8-bit is plenty for our eyes.

What the extra data gives is more processing capabilities for the image file. You can make stronger adjustments without hurting the quality of the photo. This can be especially important if you have challenges in dark tones or if you have a very wide or very narrow tonal range to deal with. But RAW is not just for problem photos. It can be used to gain the optimum tonality and color from any scene.

RAW is also a set of more basic data from the image sensor compared to JPEG. It is actually using the raw color information from the camera in a more complete way. You won't always need that, however, and JPEG can be easier to manage in your workflow.

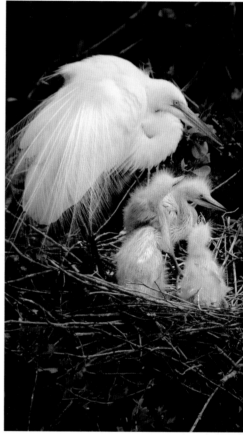

A scene with a lot of tonality in the bright areas, like this snowy egret nest in Florida, is a good candidate for RAW.

The question of which to use—RAW or JPEG—really comes down to several things:

• **Workflow**—When images are exposed well, JPEG usually requires less work in the computer. It has already been smartly processed to its 8-bit file in the camera.

• **Detail retention**—RAW will retain better detail in bright and dark areas.

• **Speed**—JPEG is faster to use and requires less memory.

• **Flexibility**—RAW offers a great deal more flexibility in processing an image.

• **Usability**—JPEG is a complete file, which is its advantage and disadvantage. On one hand, it is ready to use in almost any photo software program. On the other hand, there are limitations because less processing can be done to that "completed" file as compared to RAW files.

• **File processing**—RAW is a great format to use for people who like to really work an image in the computer because it offers a larger amount of workspace.

Many photographers take advantage of their camera's capability to record RAW and JPEG simultaneously (RAW+JPEG quality setting) by using high-capacity memory cards. Then they can use JPEG for quick processing of images and still have the RAW files when needed.

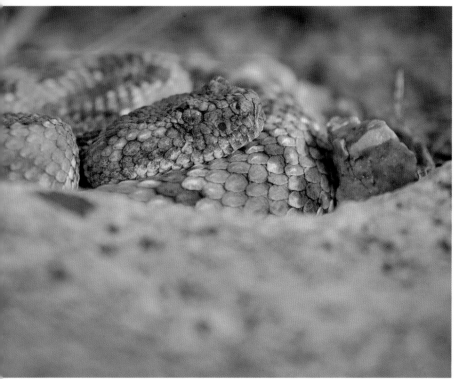

Rattlesnake, Bishop, California

White Balance

Light has color, and that color can be a critical element of a nature photograph. Setting your digital camera's white balance has a direct effect on how colors look in a photo based on how the sensor responds to the color of light.

White balance can make white and other neutral colors stay neutral without a color cast. But this has another effect that is very important to nature photographers; it can add or subtract a color cast that can be a critical part in interpreting the scene.

Cameras have three types of white balance settings: auto, preset, and custom. Auto means the camera looks at the scene and picks a white balance setting for you. Preset allows you to choose a particular white balance setting to remove, keep, or enhance a color cast in a scene (such as a sunset's colors). Custom lets you very precisely measure and control the color of light as the camera captures it.

I cannot recommend Auto white balance for any nature photography. I constantly recognize its problems in photos from students in my classes at BetterPhoto.com. Auto white balance (AWB) has three big problems for the nature photographer:

Note: With Lightroom, RAW and JPEG files are equally easy to process effectively in the computer. This makes working with RAW files well worth the effort because you can deal with them without thinking about the file type.

1. Inconsistent—AWB is designed to constantly change to adapt to different lighting conditions indoors. The result outdoors is that just zooming your lens can change colors.

2. Removes important color casts—Nature is filled with color casts that are critical to the way the world looks. The last thing we want to do is get rid of them.

3. Adds other color casts—AWB usually adds a subtle blue cast to outdoor scenes that make neutral tones not neutral and that desaturates colors.

When the colors are critical, the compromises inherent in Auto white balance will often fall short of what is possible from a scene. Important colors can have the wrong hues or an inadequate balance with the rest of the scene. In addition, a big problem with Auto white balance and nature photography is that a lot of the magic in landscapes and other scenes comes early and late in the day when the light naturally adds a warm color to the photograph. The camera will often neutralize that warmth when set to Auto white balance.

This can really affect a sunrise or sunset. Nature photographers had historically shot these scenes with daylight balanced films as a convention that actually makes the sunrise or sunset warmer than it appears to the eye. With Auto white balance, the camera may take a lot of the color out of the scene, trying to make it "neutral," which is exactly the wrong thing for this type of photography.

You may understand, as do a lot of other photographers, that you can easily change white balance in the computer, especially when shooting RAW. However, attempting to do so is not the best procedure for several reasons. First, it is an added step in your workflow that could easily get skipped inadvertently. Second, AWB often "looks" okay because your eyes adapt to it, so you then fail to correct it. Third, when AWB is inconsistent, your photos will look different from shot to shot. Fourth, the white balance options in programs like Lightroom

Overleaf: Jewelweed flower, Shenandoah National Park, Virginia

Above: Rose River, Shenandoah National Park, Virginia

ight truly makes the world what it is. Without light, green plants can't exist to add oxygen to the air. Then animals, including us, wouldn't be able to exist either. Additionally, with the right light, nature in all its beauty comes alive and sings with its own energy. In a photograph, light can make a scene go from boring to exciting with the passing of a cloud.

Think about how you feel on a gray, cloudy day when a shaft of light appears and spotlights a hillside in front of you. That grabs your attention. Consider what it is like to walk through the woods in a soft, enveloping fog where the light wraps all around you. And most people can relate to the sparkle of light dancing across the rushing water of a mountain stream.

Using light for photography starts by recognizing how light works in relationship with natural subjects. We might not be able to move the sun, but we can seek out the best possible light for our subjects. One thing that separates the serious nature photographer from someone who takes snapshots for record-keeping is the ability to see the light, so to speak, and make it work in their photographs. Good photographers also learn to see when light is not working in a scene so that they avoid that photograph or look for another angle where the light does work.

The nuances of light are infinite. Many different types of light play across a natural scene. That's one thing that makes nature photography exciting and always new. You can photograph a scene one day, then return to it the next and find something totally different because of the light.

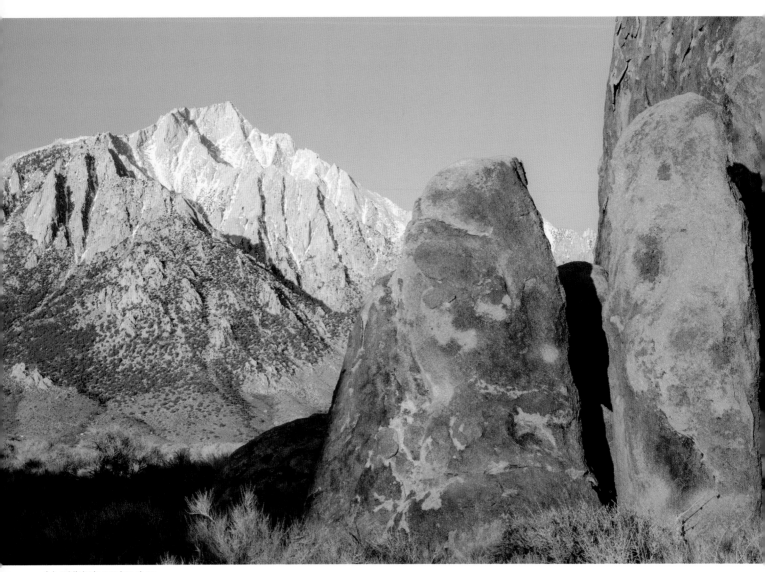

A hard light is good to showcase the edges and rough surfaces of rocks and mountains. It defines and shapes them through the use of shadows. Alabama Hills and Eastern Sierra Mountains, California

Hard or Soft Light

Watch the play of light across a landscape through the day and in varying weather, and you quickly notice the difference between hard and soft light. Hard light is the crisp light of sunlight. As haze forms, or clouds begin to cover the sun, the light spreads out, making it soften and change. Neither is good or bad. On a specific subject, hard light can be great … or awful. The same goes for soft light.

Hard light is at its strongest on a clear day without clouds. When anything gets in front of the sun, from light clouds to high humidity, it starts to lose some of its edge. To get the most from hard light, consider what it can do for your subject.

Drama: Bright sun with heavy shadows can be very dramatic. This can be an excellent effect when the subject warrants it.

Contrast: Hard light is often very contrasty, with extreme exposure differences between the darkest and lightest parts of a photo.

Shadows: Shadows gain sharp edges with hard light and can take on interesting forms and shapes themselves that are worthy of a photograph.

Form: Three-dimensional forms in a landscape come alive with hard light.

Texture: Bright sun will make textures appear with the most detail.

Bright Colors: Strong colors look very vivid, indeed, with hard light.

Angular Forms: Hard-edged shapes, like rocks, gain increased emphasis in hard light.

Soft light comes whenever the direct sunlight is not hitting your subject. This can be from clouds obscuring the sun, or when you are on the shady side of a mountain, or in a grove of trees. It varies considerably from the open shade of a canyon, to light clouds over the sky, to heavy clouds, to fog. Here are some beautiful things it can do for your subject.

Gentle, Quiet, Calm: Soft light evokes a much different feeling than hard light. A forest scene in soft light can be very calming.

Gentle Colors and Tones: The soft light of a cloudy day will make subtle tones and colors more obvious. It will even tone down bright colors.

Less Contrast: Soft light often provides a lower contrast, even to the point that the brightest and darkest parts of a photo do not have a strong exposure difference.

Soft Forms: Rounded, gentle forms are often complemented by soft light.

Atmosphere: The air becomes more visible and important as the light becomes softer.

Soft light often suggest tranquility, and usually means there are no extreme highlights or harsh shadows to hamper exposure. Central Park, New York

Direction of Light

In nature photography, you can master various conditions simply by observing the direction of the light and how it affects the appearance of your subject. Light can come from any direction, hitting your subject from the front, side, back, top, and every place in between. Each direction offers unique qualities to the light that can be used to make good images.

Above: Light coming from beyond the clouds lights the morning sky from atop Cadillac Mountain in Acadia National Park, Maine.

Left: Backlight makes a red oak leaf in New York's Central Park light up and highlights the texture of the rock.

Backlight

I put backlight first because it is the light of the pros and a light that intimidates many amateurs. Backlight hits the back of your subject and shines right toward the photographer. In other words, you shoot toward the sun or bright area in the sky. Because of old wives' tales about photography, many photo enthusiasts are concerned about photographing into the sun. Can't it hurt the camera? Won't it make awful shadows? And won't it mess up exposures? The answer to all is no, backlight doesn't do any of these things automatically. Sure, shadows can be a problem and exposures are sometimes affected, but none of that has to be. And it won't hurt your camera.

Note: Watch for flare—it is a challenge with backlight. Flare comes from the sun bouncing around inside your lens, creating bright spots, odd shapes, and haze over the image. To block it, use a lens shade (see page 75), change your angle to the sun, or look for something that shades your camera lens, like a tree branch.

Here are some wonderful things backlight can do for a natural subject.

Drama: This light is definitely dramatic, and this alone can make it worthwhile. It is both bright and dark and creates highlights and shadows. It offers dark backgrounds to contrast with bright subjects and also the possibility of dark silhouetted subjects against bright backgrounds.

Separation: Backlight separates elements in a scene because of the highlights and shadows. Even on a cloudy day with soft light, backlight will make shapes and forms appear in a scene.

Glowing Colors: Backlit leaves and flowers will glow from their translucence against the dark shadows around them.

Sparkle: Light dances and sparkles on water and other shiny surfaces when it comes from behind.

Great Texture and Forms: When the light is high enough to wrap over your subject, backlight will make textures show up and give more depth to three-dimensional forms.

Variations in light really change how you see a subject.

Right: Harlequin bug in bladderpod bush. Los Angeles, California

Opposite top: Cholla cactus lit with flash, while background gets sidelight. Red Rock Conservation Area, Nevada

Opposite bottom: Soft light in grove of Coast live oak trees. Los Osos Oaks State Reserve, California

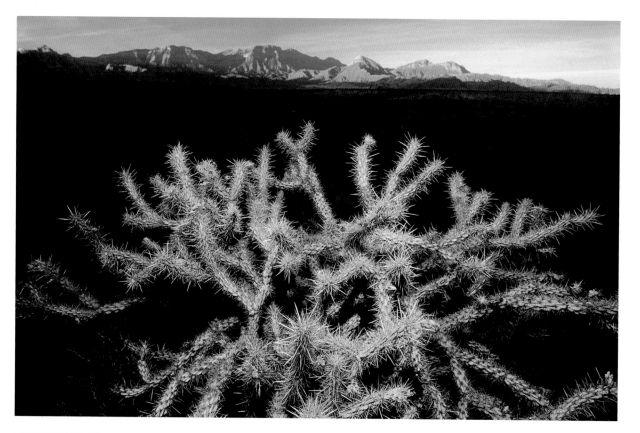

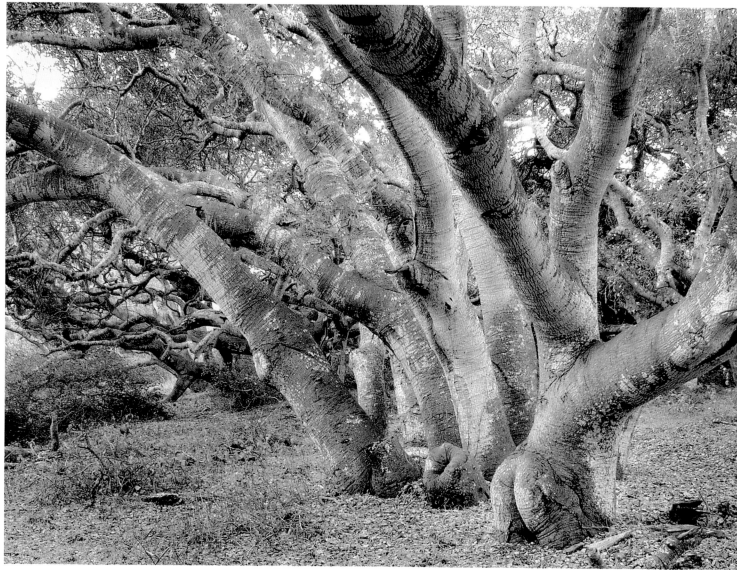

Side Light

Sidelight hits your subject from the side and creates great highlights and shadows. It is a very popular light for nature photographers because it generally offers excellent results with a great many types of subjects.

Texture: There is no better light than a hard side light for texture. Texture, whether in a landscape, on a rock, or an animal, will have a lifelike look to it.

Form: Three-dimensional form comes from the interplay of light and shade, and sidelight gives you both. Sidelight makes natural objects from rocks to mountains look exceptionally solid and dimensional.

Simply put, sidelight is particularly useful for bringing out the texture and forms that fill all of nature. Setting up to capture side light is a quick and easy way of making a landscape look good, especially when the light is low to the horizon.

Front Light

Front light is light that hits the front of your subject and throws shadows to the rear of that subject. It is often avoided by many nature photographers, and for good reason, since it can be flat and uninviting. It is at its worst in the middle hours of the day. However, when it is low to the scene, it can be quite effective. Here are some strengths to a low front light.

Bold Colors: Colors are brilliantly lit by front light because there are few shadows to obscure them.

Patterns: Any color patterns in rocks, birds, flowers, or other natural objects are brought out strongly by front light.

Minimal Texture: Without texture, underlying colors and patterns show up better.

Strong Shapes: Two-dimensional shapes of objects are emphasized by front light.

Top Light

Top light, unfortunately, can be a deadly light for nature because it usually occurs toward midday when light, for many reasons, is not at its best. Even when the sun is out, it can be a flat and dull light with too much blue in it. There are times when this is useful, however, such as when the top light comes from a softly lit sky reflecting in water. High clouds lit by a setting sun offer a wonderful top light to a scene after the sun has actually set or is blocked from the scene by something in the landscape, too.

This image of petrified wood was shot 20 minutes after the sun had dropped below the horizon. Digital cameras have outstanding capabilities in capturing interesting light and rich color after sunset. Petrified Forest National Park, Arizona

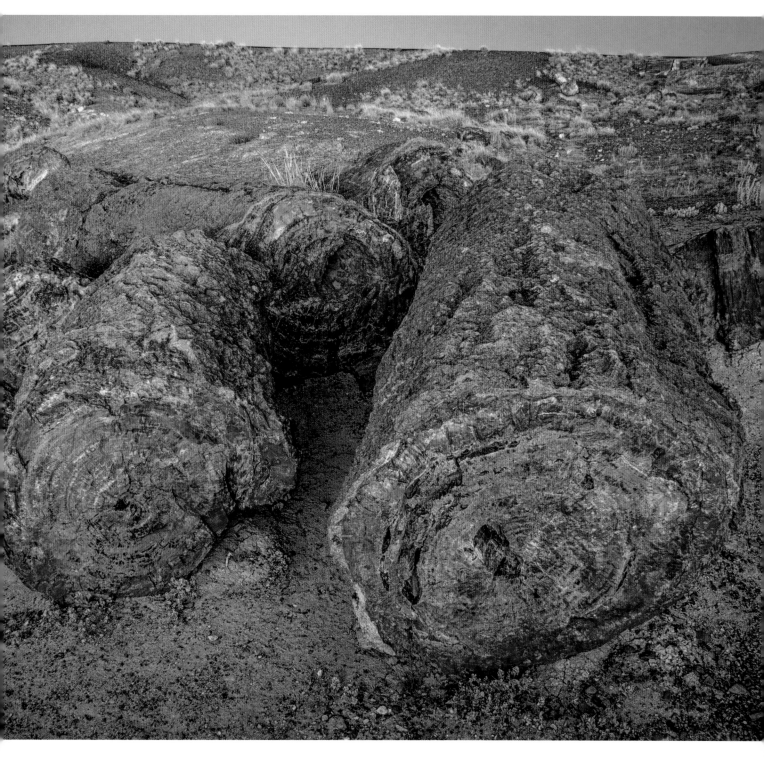

Color

The color of light coming directly from the sun is neutral, warm, or amber, but when it comes indirectly, whether from the sky or clouds, it is usually cool or blue. The two strongest influences on the color of light are the time of day and the sky. It is very common to have a scene with both warm and cold light in it—warm light in the highlights and cold light in the shadows. This adds a certain richness and liveliness to the color of a natural scene.

Warm light, like that from a setting sun, is nearly always seen as attractive. Cool light, like that from the blue sky in the shade on a winter day, is often seen as uninviting, and many photographers work to correct it through warming filters or the use of warmer white balance settings on their digital cameras.

A sunset gently lights up Delicate Arch, Arches National Park, Utah.

Time of Day

The time of day you photograph in nature has a huge effect on the light. One reason why so many landscape photographers are up at dawn, relax during the middle of the day, then photograph again at sunset is for the light. Here's how the time of day can affect the light.

Twilight Before Sunrise: Soft, diffused light that is usually very cool in color. This can be an interesting landscape light when you shoot toward the brightening sky.

Sunrise: On clear days, this can be a very hard-edged light, yellow in color with strong blue contrasts in the shade. This light is low and dramatic.

Early Morning: Directional light, with less color in it. Offers good side light and backlight, but front light is less effective.

Late Morning, Noon, Early Afternoon: Go home and go to bed if you are a landscape or wildlife photographer. The light is high, especially in the summer, and tends to make things flat and ugly. Colors are weaker. The best thing is to do close-ups at this time, maybe even in the shade to avoid harsher mid-day light.

Late Afternoon: As the sun drops lower in the sky, it becomes like early morning light, just a different direction.

Sunset: This is usually a softer light than sunrise because of particles in the atmosphere (from dust to humidity) that accumulate during the day. It is usually more orange than sunrise, and shadows often have less blue than early morning conditions. It is also low and dramatic.

Twilight After Sunset: Soft, diffused light that can be quite warm in color, especially in northern areas at certain times of the year with long twilight conditions. This can be an interesting landscape light in any direction, and this is why it is often worth staying with the location after the sun has set.

Key Gear

Sun Shade

Lens or sun shades limit the amount of bright light, including sunlight, that can bounce around inside your lens. You don't have to have the sun in the photo in order to have flare problems. A lens shade can reduce flare, increase image contrast, and retrieve color lost from flare. This is probably the most underused, yet important piece of gear around. Most lenses today come with lens shades, and if they don't, you should get one for it. A sun shade will also protect the front of the lens from fingers, stray branches, and rain.

Graduated Neutral Density Filter

At least one graduated neutral density filter (grad ND) should be in every nature photographer's bag. They are also called neutral density graduated and split ND filters (or variations of these names). Half clear and half darker neutral gray, these filters come in different strengths of gray. The 2x and 3x strengths are probably most useful to nature photographers. Such filters commonly come in a rectangular shape that can be rotated and moved up and down in front of the lens to put the dark area of the filter over a very bright area of the scene, bringing that brightness more in balance with the rest of the photograph. While holders are available for these filters, you'll see most pros simply holding them in front of the camera while the camera is mounted on a tripod.

Some people think you don't need these with digital cameras. That simply is not true. A grad ND will allow your sensor to better capture strong tonal ranges often typical in nature when sky and ground are seen; the image recorded will then need less work in the computer at the minimum. It can enable you to better define detail in extreme conditions that would be lost without the filter's effect.

Accessory Flash with Cord

An external flash can be a great help in controlling the light on a subject, especially in high contrast situations or when an important subject is in shadow. External flash is far more powerful than built-in flash, making it more likely to balance bright light in the daytime. An accessory cord to allow the flash unit to be used off the camera is an important addition to your gear because it allows you the flexibility to move the flash off-camera yet still be connected to the camera. The results of off-camera flash tend to look much more attractive than typical shots recorded with on-board flash. And wireless flash based on camera systems can be inconsistent outdoors because the off-camera flash can have trouble recognizing the light from the camera that communicates with it.

Diffuse light on a trailing daisy. Los Angeles, California

Reflectors

Any neutral object that reflects light is a reflector. Small, portable reflectors can be very useful tools when shooting into the sun, or if your subject is in the shade near sunlight that can be reflected onto it. You can even bounce a flash into a reflector to change its direction and quality. Reflectors can be made from a piece of white Fome-Cor™ (available from an art supply store), a white or silver sunshade made for a car, or even aluminum foil. If you decide you like a reflector's properties, you can buy one that folds quite nicely into your camera bag. Reflectors also have a few non light-affecting uses: you can put one on the ground to protect your equipment in sandy conditions, you can use one to block the wind from a blowing flower, and you can even use one to block light from a part of your composition.

Diffusers

A diffuser is anything that softens and diffuses light coming through it so that the light loses its hard, harsh qualities. These are perfect for close-up work, especially for flowers. They just need to be held over the flower, between it and the sun. This can give you a very pleasant light. You can try out the effect of a diffuser by using any white translucent material. I have used such things as tracing paper, a single side of a white garbage bag, or a part of an old sheer curtain. You can buy diffusers that fold up into a neat a package and come in varying strengths. There are even some box or tent diffusers that can be erected around a flower to block the wind and diffuse the light.

Color
5

While black-and-white photography can be stunning, color is really what nature photography is all about. A world without color would be a sad place, indeed! From the joyful abundance of a field of sunflowers to the brilliant reds and yellows of a sunset to the soft blues of dawn, color in nature fills a scene with energy, emotion, and life.

Color means a great deal to everything from flowers to bugs to bears. Flowers use their colors to attract pollinators to ensure that seeds can be formed and more flowers grown. Animals use color to warn others, attract mates, demonstrate dominance, blend in with their surroundings, and much more. Color marks autumn and announces spring; it can signify life and death.

Visually, color can be playful, exuberant, sensuous, or any of many other characteristics. There is a great deal of artistry available to photographers who are willing to immerse themselves in the colors of nature. However, a snapshot that simply records colors is not very magical because you can do much more than simply document the colors of nature, though that can be important, too.

The Drama of Color

Color can be dramatic. Think bold sunsets, fields of poppies, and blazing fall leaves. The danger in dramatic color scenes is that they can be so intense or strong that they overwhelm your thought process. You may feel an image looks fine in the viewfinder, but then discover afterward that the colors overpower the image, leading to color conflicts or colors that don't translate effectively from the real world to the photograph. It is always important to remember that a photograph is not the same as the subject; to get the most from a subject you need to see it as a photograph, not as a part of the real-world scene. This is especially important with color so you can get the most from visual relationships. So it is helpful to look at your LCD and consider it as a small photo, separate from the natural scene in front of you, to see what is happening with the colors there.

It is worth thinking about the ways in which colors interact to create drama in your photographs. Here are some things to consider that will help refine your use of color.

Saturation

Colors have different levels of vividness or saturation. Saturated colors are lively and fun. A great way to use them is to look for compositions that contrast a saturated color with a less saturated color that is nearby. A bright green next to a dull brown will make that green stand out more.

Overleaf (previous page): California poppies, Gorman, California

Left: Paintbrush and Texas bluebonnet flowers, Texas Hill country

The orange rock formation is considered warm, while the contrasting blue sky is a cold color. Arches National Park, Utah

Cold/Warm Contrast

Cold and warm contrast is a staple of nature. Cold colors include all those with blue in them. Warm colors include all those with red in them. The strongest cold/warm contrast comes from blue and orange. A wide-angle photo of a sunset contrasted with blue sky around it or an orange fall tree against a deep blue sky offers rich and dramatic color contrast. In winter, you can often use the warmth of the sun and the cold of the blue sky to capture richly colored snow scenes, such as snow lit by the sun contrasted with snow reflecting the sky.

Size/Color Contrasts

A very striking image can often be made by finding one small color that contrasts strongly with the rest of the image: a small tree full of early fall yellow against a sea of green leaves, or a small red cardinal on a branch against the blue sky. The small size of the bright color will make the color even more dramatic.

One-color Scenes

Nature often gives us beautiful scenes with one main color. Think of a bright green forest, red rock canyons, or the pre-dawn blues of a landscape. This can make for very interesting and forceful compositions. When working with one-color scenes (also called monochromatic, though some people reserve that term for black-and-white photography), look for tonal contrasts to give structure and form to the scene. Without such contrasts, one-color scenes can be hard for the viewer to make sense of.

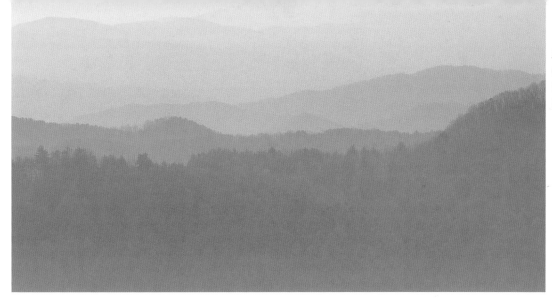

A one-color scene with light and darker tones just before sunrise in the Great Smoky Mountains National Park, Tennessee.

Complementary Colors

The strongest color contrasts come from colors that are opposite each other (complementary) on the color wheel. Compare blue to orange, red to green, and yellow to violet, for example. In addition to the contrast in color between complementary colors, note that yellow to violet also exhibits a strong tonal contrast, while red to green has little to no tonal contrast and relies totally on color for contrast. Complementary colors will make a scene look dynamic and energetic, but they can also make it look harsh and uninviting if you aren't careful.

You'll notice that quite a few of the ways to use color involve some sort of contrast. Color contrast can be an excellent way of working a composition as you look specifically for colors and tones that interact with each other.

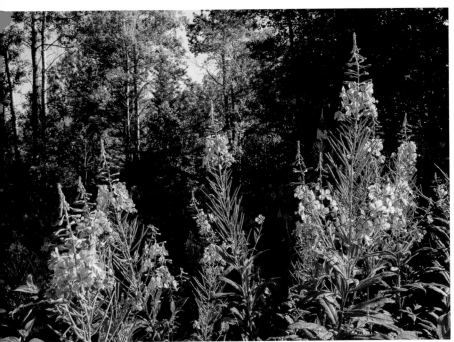

These bright pink fireweed flowers almost reach out from the scene, especially when surrounded by black shadows in the background. White Mountains, New Hampshire

Black is Beautiful

To use color effectively, you need to pay attention to black and dark areas of a photograph. Black is one of the most effective ways of concentrating, isolating, and handling color. In nature, black mostly shows up as dark shadows. Look for such shadows to contrast with your color.

Black does a number of things when used with color. When a color is surrounded by black, it appears with a luminosity and transparency that makes the color look vivid and rich. Black will set colors off to their most vibrant saturation. Even a small area of black can make colors around it look more vivid. The black gives the viewer's eye something to compare to the colors, and will always make the colors look richer. Very dramatic, yet quite pleasing photographs can be made with an image filled with black shadows contrasting with brilliant color.

As I've previously pointed out, strong, saturated, complementary colors can overwhelm a subject. However, black can tame strong color contrasts so they aren't so powerful in the composition. This is most common with fields of flowers on a crisp, blue-sky day. So much color can make it hard for a viewer to really see the flowers and any composition you might have. Black shadows running through the scene can help define and separate the colors, creating clarity for the image and the subject.

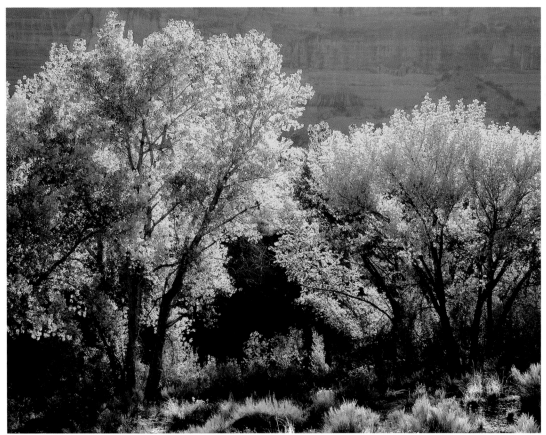

Backlight makes these Fremont cottonwoods glow at sunset. Too much exposure would make this color look washed out. Arches National Park, Utah

Exposure and Color

Exposure has a great effect on color. One misconception that many photographers have about exposure is the belief that they can always "fix it in Photoshop." However, colors rarely look as good after being manipulated in the computer as they do when shot with proper exposure in the first place. Yet the exposure/color relationship is not an arbitrary, right-or-wrong kind of thing. The correct exposure for a color is the exposure that gives you the colors you need.

If colors are underexposed, they get dark and lose their "chroma," or inherent color richness (this is similar to saturation). They can look dull, gray, and dirty. You can restore them slightly by making a lighter print or by boosting tonal values in the computer. But without increasing color saturation, the colors will not be what they were in the first place. Even with a boost of saturation adjustment in your image processing software, the colors will not be the same as those recorded with more exposure from the start.

On the other hand, if colors are overexposed, they get lighter and also lose chroma. They look washed out. Overexposed colors are difficult to recover, as they never look quite right in a print, even if printed darker or adjusted in the computer.

Some colors, however, look good with more or less exposure, which may mean a compromise with the rest of the photograph. Yellow flowers, for example, can quickly lose their color with too much exposure, and may need to be exposed so that they keep their color even if those nearby go dark. Dark animals, for another example, often have more color in their fur than most photographs show. Giving more exposure may not be an option, as the rest of the photograph will look washed out. You can try shooting for this color by using a fill flash or by shooting on days with less contrast to the light.

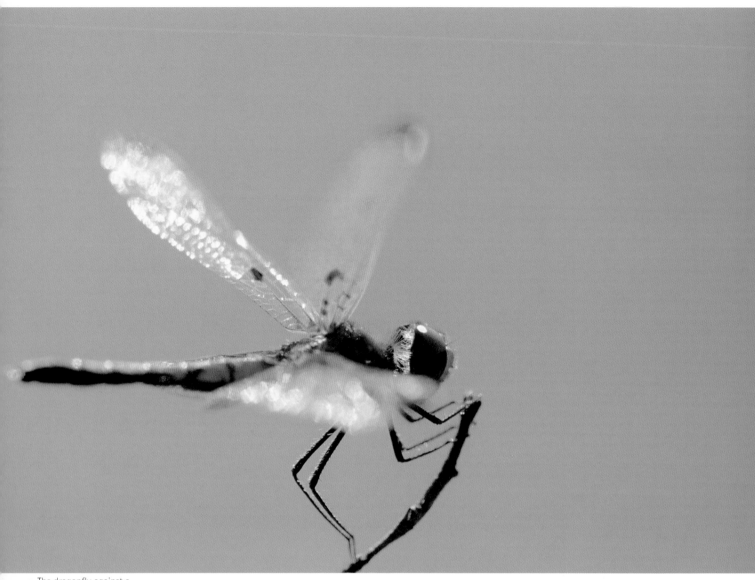

The dragonfly against a background of out-of-focus leaves will expose well with most cameras.

Getting a Good Exposure

So how do you get a good exposure? Chapter 3 looked at some of the principles of doing this, but you need to understand your camera and its exposure meter and how they combine to make exposures. The amazing computer technology built into modern cameras is astonishingly accurate in determining good exposure. Still, the system doesn't know what your particular scene should look like and it can get fooled. It wants to make scenes an average, middle brightness in tone. But not every scene is average in brightness; most need appropriate exposure, not necessarily exposure for middle brightness.

If you often get dark images with muddy color, make adjustments to give more exposure. One way to do this is by using the plus exposure part of your exposure compensation dial, or change your metering technique (try metering darker parts of your scene and locking exposure there as the meter will want to make darker things brighter). If you regularly get bright images with washed out color, then make adjustments to give less exposure (use the minus part of your exposure compensation dial) or meter brighter parts of your scene as the meter wants to make bright things darker.

Two things consistently give photographers problems with exposure and color: big bright areas in the photo, and large areas of dark. A large bright region fools a camera's metering system that just wants to make everything middle brightness in tone, which means it can't keep it bright, so the whole image will often be rendered dark. That means colors will lose much of their saturation because they get too dark. Most cameras that offer some version of multiple-point metering will minimize this effect, but it can still be a problem. The correction is to increase exposure when you have a big bright area in the photo (especially if it is snow or the sun).

Large areas of dark, such as big shadows, contrasted with a much smaller and brightly lit subject, will also fool a metering system. The system will want to make that darkness much brighter to get it to the middle brightness it is designed to record. The best way to deal with this is to decrease exposure so that the dark areas stay dark and the light areas have a proper exposure for their colors.

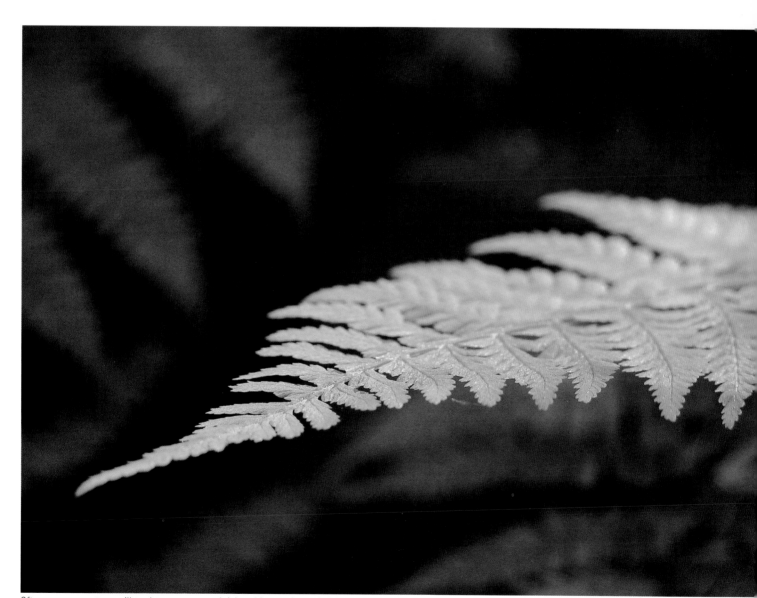

Often exposure systems will tend to overexpose a bright subject against a dark background. It is helpful to expose for the brightest areas in such circumstances.

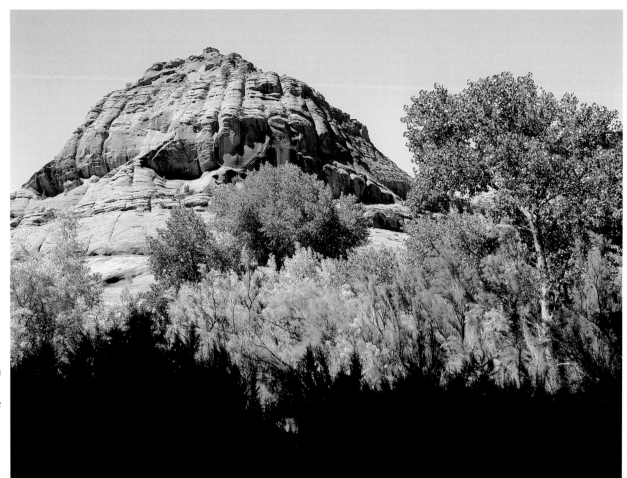

The upper photo was recorded without using a polarizer, while the photo below shows the effects when a polarizing filter is placed in front of the lens. Canyon de Chelly, Arizona

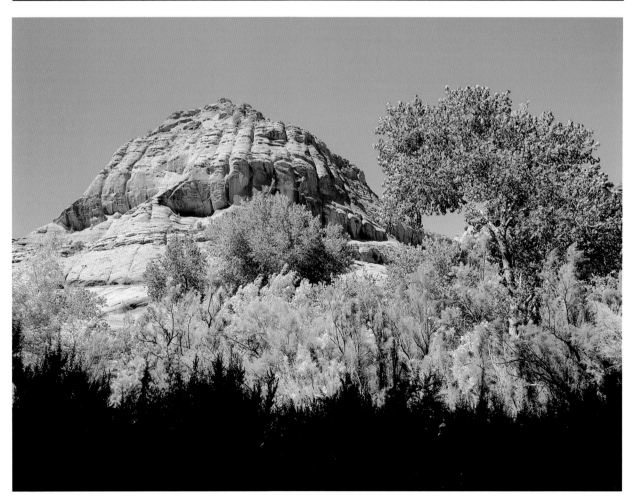

Key Gear

Filters

While you can use many filters to affect colors, the two that are especially helpful for getting the best color in your nature photography are the polarizer and the graduated neutral density filter. These filters come in two basic forms: a round screw-in filter and a rectangular system filter. Screw-in filters are quick and easy to use, but they are limited to lenses that match their specific size where the screw-in portion will fit the front of the lens. System filters work with a system of holders, filter rings, and a variety of different filter types, making them more versatile and adaptable.

The polarizer is known for affecting skies. It will intensify the blues of skies with a maximum effect at right angles to the sun and no effect looking at the sun. You change the strength of the effect by rotating the filter. For colors, though, their big benefit comes from the removal of glare and reflections from natural surfaces. Leaves, flowers, and rocks will all gain brighter, richer colors in many situations when you see them through a polarizer. You just have to rotate the filter to see through your viewfinder what, if any, effect is possible. Don't just leave the polarizer on all the time, though, because there is a cost; it is dark and cuts the light to the sensor and viewfinder to a quarter of its actual intensity. This means you have to use longer shutter speeds (risking camera shake during exposure) and your DSLR's viewfinder will be darker and harder to use.

The graduated neutral density filter has a variety of names: grad ND, grad filter, split ND, split neutral density, and so forth. They all refer to a filter that is half clear and half dark gray with a graduated blend through the middle. The gray cuts the light by one, two, or three f/stops—for most nature photographers, the two- or three-stop versions are most useful. Use this filter by placing it in front of the lens so the dark gray is over the bright part of a scene and the clear part over the dark areas. The result is that the two brightnesses are better balanced, allowing you to get an exposure that will capture colors and tonalities better. This is especially helpful with landscapes, to bring the brightness of the sky down to reveal its colors while allowing the ground to be brighter and show off its tones, too.

Graduated neutral density filter

Circular polarizer

Quick Tips for Getting Great Color Photos

1. Use a polarizing filter—This is a quick and easy way of getting more saturated colors in bright light, especially when the sky is bright. The polarizing filter removes glare from leaves, for example, to better reveal their color.

2. Limit your colors—Limit the colors in your composition to a few that work well together. Fewer colors are easier to deal with than a big mix.

3. See photo colors—Your camera will see colors differently than you do. Teach yourself to identify and respond to how colors will appear in your image rather than simply trying to capture the colors in the world.

4. Use color for emotional effect—Colors will affect the emotional or evocative content of your photo. Yellow sunflowers in a field can be photographed to emphasize the yellow for a joyful effect or to emphasize the sky for its contrast with the flowers.

5. Use a telephoto focal length for broad color effects—Use a telephoto lens or the telephoto end of your zoom to flatten perspective, bring colors closer together, and allow for out-of-focus, soft colors in the foreground and background.

6. Use a wide-angle for defined colors—A wide-angle focal length will make colors smaller, and with increased depth of field, sharper. A wide-angle gives a considerably different look with colors than a telephoto.

7. Use a flash on gray days—Turn your built-in flash on when shooting natural color on a dark, gloomy day. The colors will immediately get a boost.

8. Use a telephoto for soft colors—If you deliberately shoot through nearby leaves or flowers, for example, when using a telephoto lens with little depth of field, you will gain washes of soft color from the out-of-focus objects.

9. Surround key color—Look for ways to surround and isolate an important color in your composition so it stands out. This can be done by surrounding your subject color with dark shadow or by finding a composition that allows you to envelope the color in a contrasting, yet less saturated color.

10. Use accent color—When photographing something because of its color, whether that is an orange field of poppies or a green grove of spring trees, look for small bits of different and contrasting colors, such as a complementary color or a cold/warm contrast, to add to the composition. This will enliven the main color, such as using a bit of blue sky with the orange poppies, or a reddish tree trunk with the spring green trees.

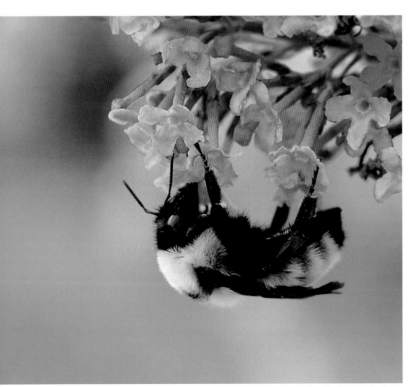

Use longer-than-normal focal lengths to soften background colors.

Opposite: California poppies, Central coast, California

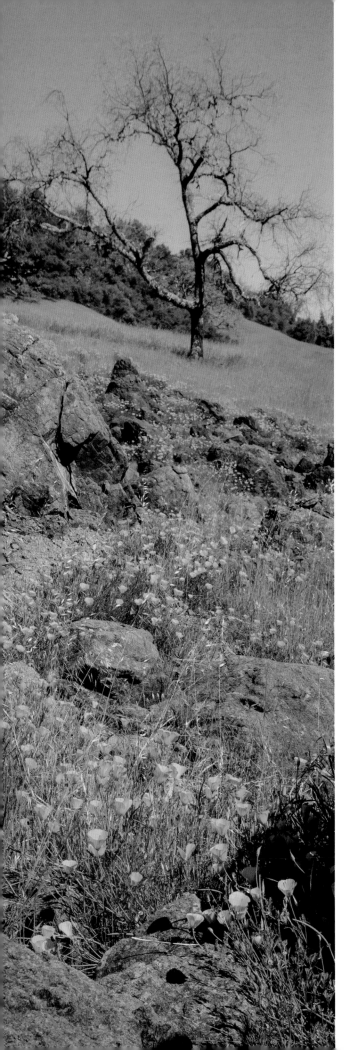

Color

A world without color would definitely be a dull place. Black-and-white photography is a fun exercise in aesthetics, but imagine if one day we all woke up to find flowers that were only shades of gray! Or fall color that was as void of hues as rainy-day clouds. Or the amazing red rock of the Southwest with all the colors of an Amish buggy.

Color is very important to the natural world. As you might remember from biology, greens are critical for photosynthesis. Maybe you have never considered why there are so many shades of green in the plant world, though. Many things modify the green, from added internal leaf pigments, to tiny hairs on the leaves, to waxy coatings, and so on. Mostly, these modifications help leaves function better in specific environments. Lighter leaves are common on plants in sunny, warm climates, for example, where a dark leaf might heat up too much and limit photosynthesis. Dark evergreens in northern, lower-light areas, on the other hand, absorb light for heating purposes as well as photosynthesis.

Many flower colors advertise the flower's identity, specifically attracting insects to aid pollination. If you get close to a flower and photograph its details, you may find blossoms with landing patterns reminiscent of aircraft carriers, and indeed, these patterns are guides for the insects. Flowers that are wind-pollinated, from willows to ragweed, generally have non-descript flowers that blend in with the rest of the plant.

Colors are very deliberately used in the bird world. Many males are brightly colored so that they stand out in the landscape, giving them the ability to hold a territory and attract a mate (research has actually shown that birds without the bright colors have difficulty doing either task). On the other hand, most females have much more neutral browns for color so that they can better blend with the surroundings while on the nest and tending their young.

The sky is filled with color effects. Technically, the sky isn't colored like a solid object such as, say, an apple. It shows off its color due to the way light passes through it. Blue sky is blue because blue light is broken up and scattered by the molecules in the air (red light is not). We see it reflecting from all over, hence, the whole sky is blue. When the sun gets low in the sky, light has to pass through so much air that all the blue light is scattered and never reaches your eye.

Connections

Landscape

6

The background peninsula is off center, allowing the foreground ice flow to take center stage in this picture from Casco Bay, Maine.

Relationships Are Unclear: A subject in the center dominates the rest of the photo, causing other important parts of the photo to lose their effectiveness. A nice foreground rock, for example, loses its strength if the background mountain dominates the photo from the center.

Edges Can Show Problems: If you focus on the center, you tend to forget the edges. The edges of a photo are often the places where annoying distractions show up. You may also find that elements get awkwardly cut off in a way that could be fixed by just moving the camera to include more or less of that edge.

Edges Are Interesting: If you start looking around the edges of your photo, you'll often find some interesting things that deserve more attention in the composition.

The Guideline of Thirds

There is a long-existing compositional technique that has come to be known as "the rule of thirds," which serves as a helpful reminder to get the subject out of the center of the photo. It is based on dividing the image area into thirds, top to bottom and left to right. Then you, the photographer, use those four lines and intersections as a way of organizing your composition. You can put the horizon at the lower third or the upper third of the frame, then put strong visual elements, such as a dramatic tree or a mountain, at the intersections of the lines.

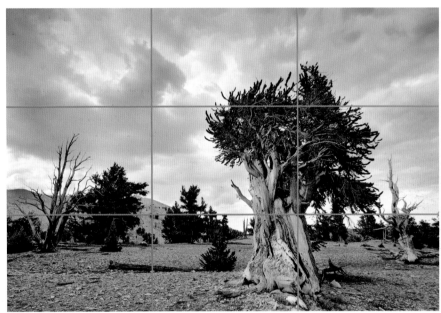

I have mixed feelings about the rule of thirds. On the one hand, it simplifies and makes decisions about compositions easier. But on the other hand, it can be restrictive since the real world is not made up of thirds. Beginning photographers sometimes take it too literally and try to make a scene fit this "rule" when it really isn't appropriate.

It probably would be better called the guideline of thirds, and if you think of it that way, it can be helpful without causing problems. Start with an image fitting the thirds idea, then move the camera around and watch your viewfinder to see if the actual scene looks better when its parts are in different places in the frame. Use the edges of the frame as reference lines, and experiment by moving compositional elements closer to them.

Most of the land mass falls in the bottom one-third of the frame with the open sky occupying the upper two-thirds. Meanwhile, important elements, such as the ancient bristlecone pine on the right, can be found along the vertical line that is one-third from the right edge. Of course, this is a guideline, not a perfectly rigid rule. Ancient Bristlecone National Forest, California

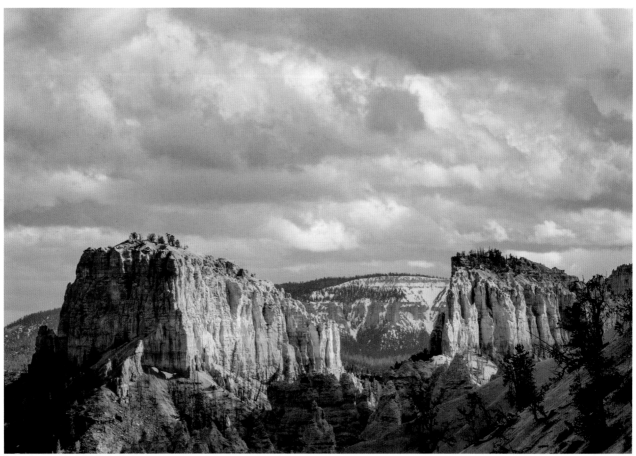

Bryce Canyon National Park, Utah

Balance

Perhaps a better rule of composition is balance. This is a less exact concept than the rule of thirds because it has no set pattern or guideline. However, balance for your photograph is something you can use for any image, even if the real world doesn't fit the rule of thirds.

Balance is simple in theory, but takes some thought to make it work in a photograph. With practice, it will become intuitive. Balance relates to how well the whole photograph works; i.e. from side to side, top to bottom. Do elements on the right visually balance things on the left, and elements on the bottom balance items on the top? In a symmetrical landscape, the balance is pretty obvious, but often uninteresting.

To see balance in a photograph, you need to look at the image as a whole and not just the main subject. Examine how strong parts of the composition interact with the rest of the image and consider if one side seems heavier than the other. If a big, contrasty

subject sits in one half of the frame while an area of unfilled space occupies the rest, the photo will look unbalanced. Think of it as a child's teeter-totter—a big kid on one side will not balance a little kid on the other if the two sides of the playground structure are equal. The little kid has to have a different length of teeter-totter.

You can't change the basic dimensions of the photo when you take it, but you can change where objects end up in it. There are several things to think about.

Small Objects Can Be Equal Partners to a Big Subject: Fill most of the frame with the big subject and use the small object as a balance in a restricted area of the composition. This can make a nice contrast.

Big Sky Will Often Balance a Smaller Area of Land: Space in a photo is a pictorial element and can balance other parts if thought of in that way.

Though the conventional way of photographing nature scenes is horizontal (it is even referred to as landscape format) as seen above, you can go for the unexpected and capture something distinct by shooting in the vertical, or portrait, format as shown in the image opposite bottom, which shows the same location.

Verticals offer a unique way of seeing the landscape. They obviously work great with tall trees, high cliffs, and towering clouds. They help with images in which you want to develop a strong foreground/background relationship because there is extra distance in the frame from bottom (foreground) to top (background). You can use a vertical to increase the feeling of sky, or intensify the length of a stream.

With wide-angle lenses, verticals also give a strong feeling of depth because you can set your camera to look down on something at the bottom of your composition and out at the top. Verticals give you variety, offering opportunities to enliven your images.

Hint: Practice helps you see horizontal and vertical compositions. Whenever you are taking pictures of a scene, try holding the camera in both positions just to see what they look like and how they are different.

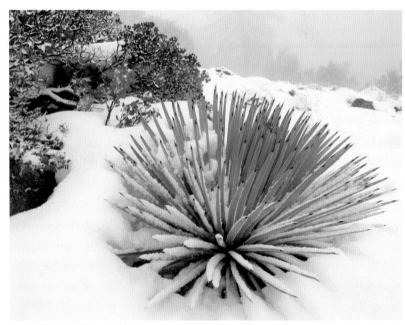

Angeles National Forest, California

Deep Versus Flat

A landscape is usually deep in front of you, yet in photographs, we have to flatten real life into two dimensions. You can definitely make that photo appear to be very deep and dimensional, or you can take the opposite approach and emphasize the flat qualities of the photograph.

Dramatic sunrise through driftwood, Northern Florida

I'll provide tips for making scenes look more dimensional, but you might be wondering why anyone would want to make a three-dimensional landscape look any flatter than it has to in a photograph? Actually, some very interesting photographs come from flattening the look or perspective of a scene. Perspective is the relationship of things in your photo as they go from near to far. For example, close things are typically bigger and better defined than more distant objects.

When you deliberately go after a photo that masks or disguises that relationship, the landscape becomes flat and two-dimensional. In many situations, this is not helpful for making a landscape look magical. However, when this flattening is used creatively, the photograph gains some abstract and graphic qualities that can produce a very effective composition.

You gain a flatter perspective on a scene by using a telephoto lens or by finding a flat scene to start with (such as a rock cliff). Telephotos are very important for controlling perspective. They reach out and bring in distant objects, which in the case of a landscape often means missing close-by objects that could contrast with the distance for a perspective relationship. You can actually change the perspective of a scene by zooming in with any zoom lens.

A more dimensional landscape comes when perspective is enhanced and emphasized. Any time you can contrast something close with something far and the relationship of distance is obvious, the photo gains more depth. Wide-angle focal lengths are a great asset for increasing depth in a photo (not to be confused with depth of field, which is about sharpness in depth, not perspective). They allow you to pick up close objects in your composition that can contrast strongly with distant subjects.

Wide-angle focal lengths will make foreground objects large while distant things look small, creating a strong perspective relationship. In addition, these focal lengths let you get in close to foreground objects, emphasize them, and show their detail compared to distant things, all of which will underscore perspective.

Using the Sky

Sky is a key part of many landscapes, and can make or break your photo. To get the most out of a sky, pay attention to it, see what it offers the landscape, and work to bring the right things out of it to complement the ground.

A common problem with landscape skies is a washed out, blank look. At best, this is boring; at worst, it can destroy any magic in the rest of the photo. You can deal with it in two basic ways. If the sky is featureless clouds, keep it out of the photo, or at most, use only a small section showing in the composition. This defines the top edge of the landscape and adds depth to the photo.

fer the pan-tilt heads that have different controls for front-to-back and side-to-side movements, allowing each plane to be adjusted separately. Either is a good choice, depending on your personal preferences. With ball heads, avoid the smallest ones. They don't work well to stabilize a camera and often don't offer maximum support to a heavy camera/lens combo. Magnesium heads are more expensive, but are light and balance a carbon-fiber tripod well.

See pages 41–43 for a discussion of selecting a tripod and head.

Filters

Graduated ND filters in two- and three-stop strengths, plus a polarizing filter, are tools you will find in most pro's bags when they are shooting landscapes. See page 95 for a more complete discussion of filters.

Lenses

It is possible to photograph landscapes with just one lens, but this will limit your options. Landscapes, unlike close-ups or wildlife, do not require special equipment, though it is helpful to have at least a wide-angle and telephoto lens, or equivalent focal lengths on a zoom lens. You may find

you prefer wide-angle views and favor those focal lengths. You will still want at least a moderate telephoto as an alternative that offers a fresh view to your normal landscapes. On the other hand, you may favor telephoto points of view. The same advice applies, but to those focal lengths.

Wide-angle lenses give you the classic wide-view landscapes. They are essential if you are stuck in one location and can't back up to get the whole scene into your composition. Wide-angles offer great opportunities to work the foreground/background relationship. They let you get close to a foreground subject while still being able to see the background. This emphasizes depth in a landscape. Wide-angles give more depth of field in a scene, so they are important when you want a lot in focus from front to back. If the day is hazy, wide-angles also let you get in close to your scene so that you see less of the haze.

Telephotos offer the chance to focus on details in the landscape, and can be especially important when you can't get physically close to a scene. They are great for isolating a special, dramatic part of the scene. Telephotos flatten out a landscape's depth, making objects look closer together, which can be a useful dramatic effect. They make foreground/background relationships harder to define. They limit depth of field, which is a problem if you want most of the frame in focus. Telephotos will emphasize haze in the air, which can make for interesting tonal effects shot against the sun.

Zooms allow you to combine multiple focal lengths into a single package. This offers flexibility when you are photographing a landscape. You can quickly frame a composition, change perspective effects in an instant, and minimize the number of lenses you carry. While you still hear folks saying they aren't as sharp as single-focal lengths, that's really not true. However, zooms do tend to be slower (smaller maximum apertures) than single-focal-length lenses.

Quick Tips for Great Landscape Photos

1. Lock your autofocus—Point the camera at the most important part of your landscape, press and hold the shutter lightly to lock focus, and then realign the composition to the desired framing. This helps ensure that your subject is sharp and is especially important if you have a strong foreground that needs to be in focus.

2. Use foreground sharpness—When working on a strong foreground/background composition, you may find that you cannot get enough depth of field to cover the distance. Focus so that the foreground is sharp and accept what you get with the background. Unless you are deliberately trying for an effect (see the next tip), a slightly soft background is better than a slightly soft foreground.

3. Use an out-of-focus foreground—For something out of the ordinary, try the effect of creating a soft foreground to contrast with a sharp background. Use a telephoto lens and be sure you are focused on the background, then choose a large f/stop. This will limit depth of field, creating an interesting contrast from out-of-focus foreground to sharp background. Slightly soft foregrounds usually don't look right, but a seriously out-of-focus foreground can look creative.

4. Look for foreground color—If you look for a bright color in your foreground, you can quickly and easily create a strong foreground/background relationship.

5. Use a level—Even on a tripod, a camera can be misaligned to the horizon. Crooked horizons are frustrating, so avoid them by using a level on your camera. Many cameras include a level that can be displayed on the LCD, or you can buy levels that fit into your hot shoe at many camera stores.

6. Experiment with blurs—If the day is windy and causing problems with sharpness, don't fight it, work with it. Try stopping your lens down, adding a polarizer (to cut the light), and start photographing as the grass, trees, or other parts of the landscape move. You'll need to play with exposure and timing—no two shots will look the same.

7. Use a frame—If you look for something dark in the foreground that can go along the edges or top of the image, you can use this to create an interesting frame for your landscape. A good example of this would be a silhouetted tree in the foreground that does not have the same light as the background.

8. Bracket your compositions—Try taking multiple compositions of the scene, bracketing them by trying more and less sky, more and less foreground, and so forth. The landscape doesn't move, so this is a great chance to really experiment and learn good composition.

9. Find a better composition—Once you have found what you think is the best composition for your landscape, ask yourself where the next composition is and if you can find a better one. This will make you work the landscape like a pro.

10. Try an extreme telephoto—Most photographers shoot a landscape with wide-angle or moderate focal length lenses. If you have a long telephoto, including tele-extenders, put it on your camera and look across the landscape. You will find fascinating details with a dramatic perspective.

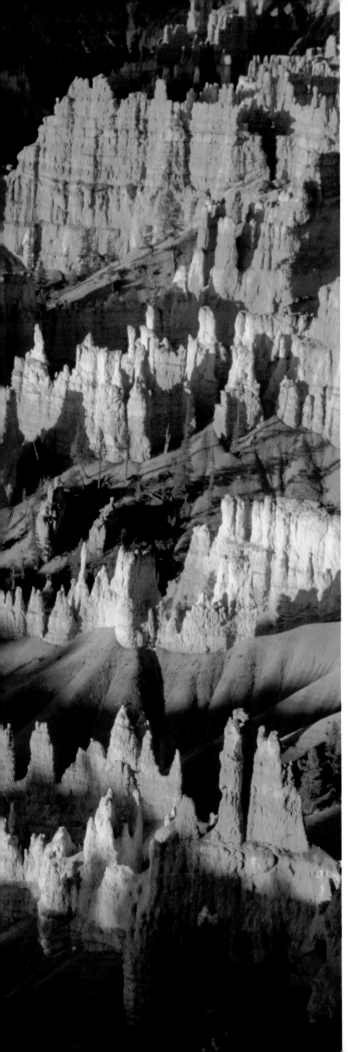

Bones of the World

Rock formations show off underlying geological structures, but to me what they truly represent are the bones of the world. I have seen beach rock formations heading into the ocean that look just like the spine of a sea serpent. I have marveled at boldly shaped rocky slopes in the desert that are positively skeletal. I have sat on gray granite outcroppings cutting through a forest that seemed more like ancient fossils than rock.

These rock patterns can be fascinating both aesthetically and intellectually. Rocks give you the underlying lay of the land and show off some of the forces that created the landscape you are photographing. Their formations often represent the key structures that form the scene. Isn't that, after all, what bones really do? They structure our bodies and give shape to the forms of all sorts of animals.

Most landscapes occur from a number of distinct forces, with the most common being erosion from wind and water. The rock resists these forces and keeps the shape of the landscape as long as it is able. Rock resistance forms everything from mountains to cliffs to waterfalls, and much more. It changes the direction of rivers and roads.

It is interesting how much photographers see rocks as imparting structure to a landscape. Look at a series of landscape photographs and you will see rocks at some point. Often, those rocks are important structural components of the photo's composition as well. Not all landscapes will have clearly defined rock formations—they can be buried by water or centuries of deposited soil. However, if you have a landscape with bold rocks in it, those rocks will be key to both how the land was formed and how you will photograph it.

Bryce Canyon National Park, Utah

Connections

Flowers
7

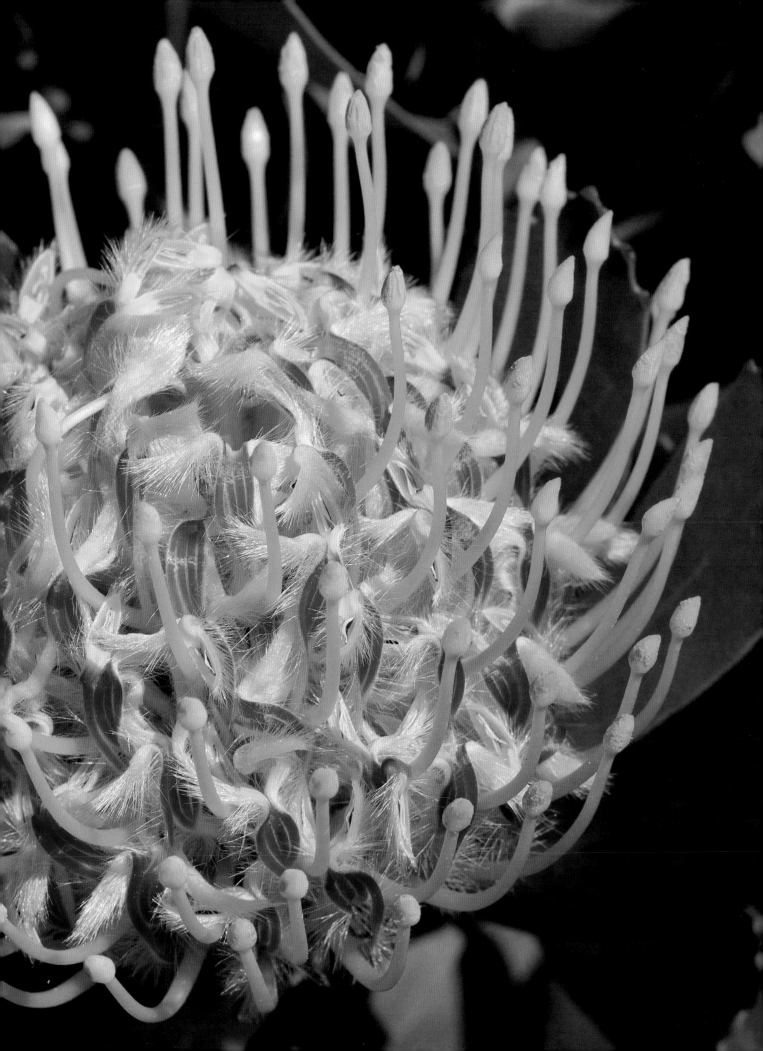

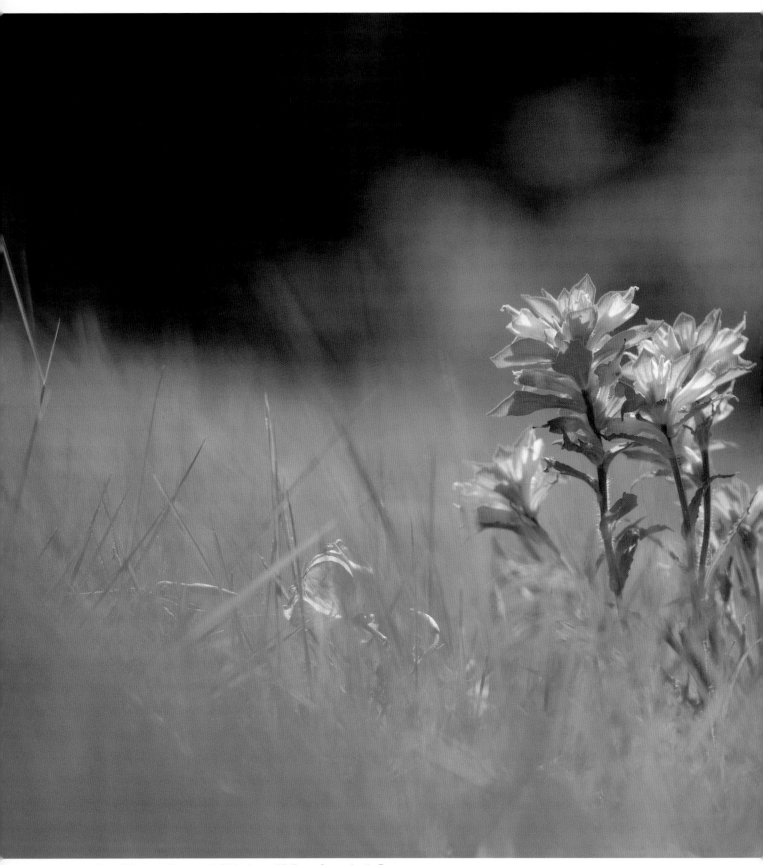

Above: Paintbrush flowers, Lady Bird Johnson Wildflower Center, Austin, Texas

Overleaf: Pincushion Protea, Leaning Pine Arboretum, San Luis Obispo, California

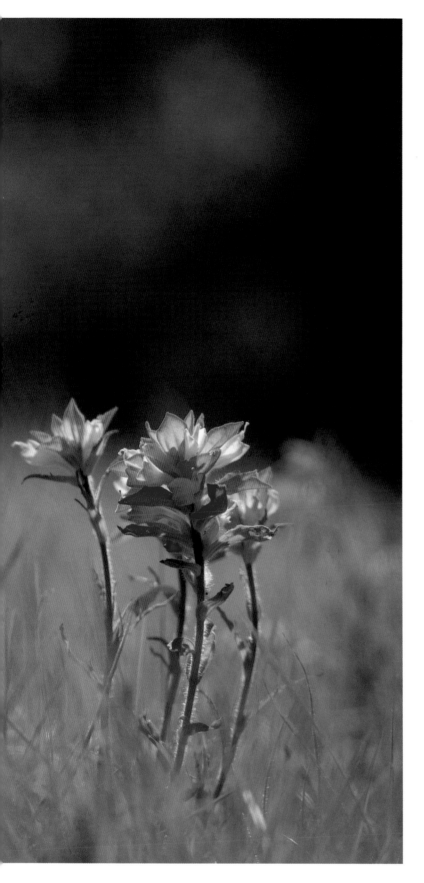

They carpet the floors of spring forests, force their way through late winter snows, decorate the tops of mountains and rain-forest trees, weave a tapestry of color into prairies, and provide dramatic and stunning color in arid deserts. Flowers bloom nearly everywhere. That alone makes them attractive subjects. But get close, and flowers show extraordinary arrangements of color, form, and design; magical displays that range in size from millimeters to feet. They wake us up from winter, delight us with their colors and forms, and so very much more. Photographing flowers brings us close to this marvelous life, and allows us to capture some of the energy and exuberance found in flowers.

Why Photograph Flowers?

At first thought, the reasons to photograph flowers seem obvious, right? Everybody likes to because they are beautiful, because of their color, and because of their connection to our lives. That, however, can be the very problem. Flowers should be easy to photograph. Yet just framing one and squeezing the shutter is no guarantee of a good photograph. Sometimes expecting the beauty of the flower to carry into the photograph is the problem.

A flower and a photograph of a flower are not the same thing. This is a very important thing to understand. If the motivation for photographing a flower is solely because it is pretty, then that frequently leads to failure, because the photo can never be as good as the true flower.

Hint: The wind is often a frustration when photographing flowers, but don't let it keep the fun from your photography. If you watch the blowing flower, you'll often find there is a moment that it pauses in its movement. Shoot at that point. For really windy conditions, you can block the wind. Have someone stand in the wind, hold a reflector, or try holding the flower stem to keep it steady. There is a product from Wimberly, Inc. that clamps to your tripod called the Plamp. It will hold most macro subjects for you, such as steadying a flower stem.

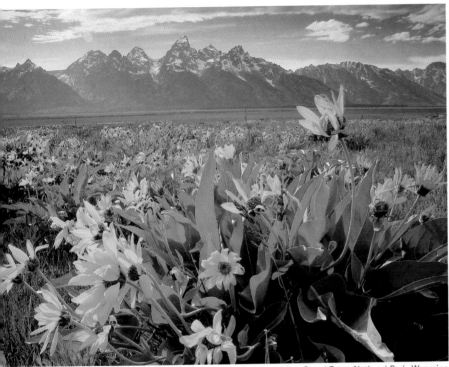

Mule's ear flowers in a wide landscape setting. Grand Teton National Park, Wyoming

Close-up portrait, blood flower milkweed. Los Angeles, California

On the other hand, you can photograph flowers for many reasons, from simply documenting them precisely and clearly for identification purposes, to going for an abstract interpretation that expresses how you feel about their sensuous colors. Both of these examples demand a different approach to the photography, and each gives a new look at the same flower. So for success in photographing flowers, you need to know why you are photographing them and how you can portray your reason in the photo.

Therefore, the "why" behind flower photography can be simple or complex, but for me, photographing flowers gives me deep pleasure. There have even been times in my life when the world seemed to be coming apart, so I took time to get out and shoot pictures of flowers. I relaxed and felt better, even if the world was still a challenge. When you stop to think of the reasons why you photograph flowers, you will have many ideas of how to make that composition work for you and your subject.

Experiment with new angles by shooting from below the flower. This produces a bold, statuesque view of the flower against the sky. Thistle sage, Shell Creek, California

Flower Portraits

From the common sunflower to the exotic calceolaria, all flowers look beautiful. But just pointing a camera at a great looking flower won't get you a good photograph. The best way to get a good image is to treat the flower as a portrait subject. Whether you like to photograph portraits of people or not, you know that it is not simply a snapshot of the subject. Many things go into making a nice portrait, such as light, expression, and clothes. Those same considerations can affect a flower portrait and give you ideas on what to do.

Camera Height

A portrait changes dramatically depending on the camera height to the subject. One effective way of photographing a person is to put your camera right at their eye-level. The same thing is true about flowers. The most common angle of flower photography is from above looking down, which can make it dull. While that is the way we see flowers, it is not the most effective view of them. Getting down low to blossom level will often elevate your images.

Background

A background can make or break a portrait photo, and this is absolutely true for flower pictures. A background needs to set off the subject so the viewer of the photo can see the subject clearly, or it must have a clear relationship to the subject so that background details support the subject. One thing a background should not do is distract from the subject.

Look carefully at what is behind your flower subject, not just what is in focus. A bright, out-of-focus red blob from another flower, for example, can take the eye away from your white flower subject just as easily as an out-of-place, sharp blade of grass. Adjust your angle in relation to the subject to minimize distractions.

Background attention is not just about distractions. Look for things that can enhance your subject. A dark shadow, a complementary color, or an area of consistent tone can set your subject off from the background. Shapes in the background can balance your subject in the composition. Other elements that add information about your subject are also important.

Clothes and Make-up

Portrait photographers will often have their subjects dress a certain way, and in the glamorous end of the photo portrait business, make-up is a part of the process. You don't need to carry a wardrobe or flower paints, but thinking about appearance can help you get a better flower photo. This means choosing the right flower for the close-up.

Blossoms with snail-eaten petals and faded colors can give an interesting insight into the life of a flower, but they also aren't particularly attractive up close. An environmental shot showing the ravages of a flower's life cycle can be an interesting photograph, but that might not be the most attractive way to feature your subject.

Usually it is preferable to look for the most perfect flower to photograph: color, shape, form, and condition are all important. In addition, do a little cleaning around your subject; remove any garbage that might be there, such as dead leaves, distracting stems, and so forth.

Light

Light on your subject can dramatically change the mood and quality of your image, creating a superior photo from what otherwise might be merely average. There is no rule about light that will work for every photographer and every flower. Bright sun on a sunflower is very natural, yet may look awful on a trillium.

Consider if the flower looks best in direct sunlight or in a more diffused light. For light coming directly from the sun, try using backlight to make the flower glow, or sidelight to give it texture and dimension. A reflector can fill in the dark side of the flower when it is shot with backlight.

If the sunlight is too harsh, block it or use a portable diffuser. You may also have to wait until the sun goes behind a cloud, or for the light to move off the subject, or simply decide on a different time of day. Just as the sun sets and right after can cast a wonderful, warm skylight on a flower.

Flash

Many people portraits are made using flash because of the way light from a flash can be controlled. Flash works for flower portraits as well, giving you total control of the light source. The easiest way to do this is using a flash with a dedicated extension cord connected to the camera. This gets the flash off and away from the camera lens. You can move the flash higher for a top light, to the side for a sidelight, and so forth. You just have to be careful where you aim your flash.

You will notice that light has a variety of "moods" and intensities, such as the bathing quality of this early morning sunlight filtering through a forest onto wild rhododendron flowers. Brunswick, Maine

In addition, you can use flash to brighten dark areas of your subject to balance the existing light (check your camera manual as the specifics vary from camera to camera). Flash is made easy with the use of a digital camera because you can see exactly what the flash is doing to your flower subject on the LCD.

Expression

While expression and gesture seem perfect for the people portraits, it may seem an out-of-place concept for a flower subject. Flowers have "expression," but in a different way. How a blossom is positioned on the stem, or how it sits up or droops down will change your photo. You will often find slight variations in a group of flowers. Each blossom may look equally good, but close examination may show one with distinct, hard-edged markings, while another uses a softer palette of tones for the same markings. These flowers will photograph quite differently, so it is worth checking.

Hint: Sometimes the contrasting background area is too small. A way to deal with this is to use a telephoto lens for perspective effect. If you back up to keep the flower the same size as it was with a wide-angle lens, the telephoto will magnify the background, allowing you to use what would otherwise be a small area of contrast to now fill the area behind the flower.

Contrasts for sharpness, tone, and color all work together to create a dramatic image of prickly poppy flowers in the chaparral of Southern California.

Isolating Flowers

Isolating a flower in an image can help you capture its unique beauty and show off its display of design and color without unnecessary distractions. With good isolation technique, a flower can show up strongly in a photograph, even if it is not a close-up.

There are three key ways of isolating your subject from the rest of the photograph, and they are all related to contrast. You want to find a way to contrast the flower against the background. This will immediately create visual dominance for the flower and allow you to clearly define your composition.

Tonal contrast: Tonal contrast simply refers to the brightness of the flower compared to what is around it. The flower can be lighter or darker than the background to stand out against it. Because of the way light works in nature, there are almost always changes in brightness across a scene. Plus, nature is rarely consistent in tone, so by moving around, you can almost always find a contrasting tone.

Tonal contrast will work with flowers in many conditions of light, even if you shoot in the black-and-white medium. Because flowers are small, you can more easily find contrast compared to larger subjects, such

as a landscape. Often just slightly moving your position relative to the flowers will give you some contrast to work with. You need something in the background that is lighter or darker than your flower subject.

Color contrast: Anytime you can put a distinctly different color behind your subject, the subject will stand out. Flowers are generally very colorful, so this is an excellent technique for contrasting them. The challenge occurs when similar flowers are massed together; flowers behind your subject may be the same color as your subject, offering no contrast.

You have to determine methods to get around this in your composition. There are several ways of looking at color contrast that may help you find the right contrast for your flower. By moving your camera slightly, you can often find multiple colors to use. The most obvious color contrast is one where the subject and background are different hues. For example, a red flower will dramatically stand out against a solid band of green foliage behind it, or an orange flower will be bold against a blue sky.

Another color contrast is one of saturation. Saturation is the intensity of a color. This usually works best if your subject flower is more saturated than the background behind it. If the subject is more intense than the background, it will stand out.

Sharpness contrast: Any time you can make your subject sharp and the background unsharp (blurred), your subject will stand out. This can be a very effective technique when your flower subject is the same tone or color as whatever is behind it. Many photos of flowers benefit from this technique, but two things can cause problems:

1. Automatic program exposure with DSLR cameras—In program exposure modes such as Close Up or Program, the camera may choose an f/stop that creates too much depth of field, resulting in a lack of sharpness contrast. Yet, you won't see that in the viewfinder. That is because the DSLR shows you the scene through the lens at

Desert agave, Anza Borrego State Park, California

its widest aperture (least depth of field), regardless of the actual aperture used. DSLR cameras are set up this way so you can see the scene more clearly and so you and the camera can focus better. The camera stops the lens down to the proper aperture when the shutter is released.

2. Trying for complete focus—The idea that everything must be in focus in a picture is a common misconception, particularly among beginning nature photographers. While certain scenes do look good with maximum depth of field, that can be a problem if you are trying to highlight a single flower so it stands out from the detail in the background.

To use sharpness as a contrast, the subject must be sharp while things behind it are blurred. The quick and easy way to deal with this is to use the widest aperture or f/stop on your lens. Choose something like f/2.8, f/4, or f/5.6 (or whatever your lens offers as the widest f/stop). This will result in a fast shutter speed to maintain proper exposure. In really bright light, you may need to use a neutral density filter or a smaller f/stop to cut the light. Be sure to focus carefully on your subject, because if the sharpness is off, the contrast you are trying for will not be successful.

Telephoto focal lengths can be a big help in isolating your flower using sharpness contrast. These focal lengths reduce depth of field. Another thing you can do is move around to find an angle to your subject that has more distance between the subject and background. The common 45° down angle on flowers makes the background fairly close to the subject unless the plant is very tall. If you get down to the level of the flower, the background is often much farther away, and therefore more out of focus.

Sometimes one of these isolation techniques works best on a particular subject, sometimes another. Try all three with different subjects. You'll get a feel for them and will be better able to choose which one works best for a given situation.

Hint: Many DSLRs have a depth-of-field preview button. This stops the lens down to the taking aperture and will give you an idea of what is in focus. It takes some practice to use, as the viewfinder will get very dark. You have to force yourself to look for sharpness differences. However, you can always see the depth of field in your shot on the LCD. Use Live View if your camera has it because it will let you see depth of field changes quite easily with the depth-of-field preview button.

Elderberry, White Mountains, New Hampshire

Pink mallow flowers seem to glow in backlight, especially when shot close to the subject.

Backlighting

Using backlight properly is a great technique and one that you will definitely want to master for photographing flowers. Backlight, as discussed earlier, is the pro's light. They use it all the time. You can too, and the results with flowers will make your images snap, crackle, and pop with color and vibrancy. This refers to all flower photos, from close-ups to big groups. Backlight does several important things to bring new life to the subject.

Backlight makes colors glow: Color is one of the wonderful parts of flower photography. With backlight, that color will look radiant.

Backlight separates picture elements: Because backlight is a light of highlights and shadows, it will create separation and definition in your flower shots.

Backlight dramatizes the subject: Since backlight always has contrast from light and dark areas, it makes photos more dramatic. Not commonly used by the average photographer, backlight gives a look to the flower that is different and striking. If you get

down really low, you can even get the sun behind the blossoms, adding a strong touch (you may also get flare in the shot, which can be considered part of the drama).

Backlight may add sparkle to the shot: With the sun behind the subject, the light will sparkle at times off petals, especially off any dew on your subject.

Backlight increases contrast: Contrast can be helpful in bringing more life to a photo on days that have less contrast. Just shoot toward the brightest light.

When you shoot toward the sun, the right exposure can be difficult to achieve. Increased contrast can cause problems, and flare may become distracting. Below are techniques to deal with these challenges when shooting flowers.

Exposure: Expose for the highlights or bright parts of the flowers. With digital, you can see what you are getting, so check to see if the colors look right. Enlarge the image in your LCD and learn to use the histogram explained on pages 51–52. It can also help to bracket your exposure.

Increased contrast: Too much contrast will give you an ugly photo with visually dense black shadows and harsh highlights. Train yourself to see when the contrast is too harsh for the flowers, and do that by taking photos (you can learn very quickly when using your camera's LCD review). You can fill in dark shadows with the use of a reflector or flash.

Flare: A lens shade will help you avoid flare by keeping the sun off the lens. You can try blocking the sun with your hand or a hat, but watch the edges so your sun-blockers don't creep into your photo!

Setting

Where a flower lives can be an important thing to include in a photograph. A close-up of a delphinium flower, for example, could be done in a garden or at its native site in the mountains. While both shots could be great, the close-up won't define the location. To the viewer, the pictures might have been taken at the same location.

There are two ways of showing setting. One way is to make a composition that includes the flower and its environment; the other is to take two photographs, one of the flower up close, the other of its surroundings.

Including the flower and its environment can be tricky. It is easy for the surroundings to overwhelm your subject. Use the isolation techniques described earlier in the chapter to help set your flower apart from its surroundings. Playing around with depth of field will allow you to make your flower sharp and the background less sharp, yet still recognizable. The depth-of-field preview can be very useful for that.

You might also try a composition that uses the whole frame to establish a relationship between subject and background, and does not simply plop the subject into the center. It can make for a clearer composition if you use the image area to visually relate the subject and environment; for example, placing the flower in the lower left corner and a background mountain on the right.

Taking two photographs is another good option. It is easy to see you got the shot with the close-up—it looks great on the LCD review, the light and color are wonderful, and so on. But without the surroundings, it will lack context. Often, it is impossible to make a good composition that both flatters the flower and shows the surroundings. In that case, make the best image possible of the flower, then make the best image you can of the environment. This is a great technique for slide shows and multiple prints of a location. It gives the viewer a sense of place for the flower.

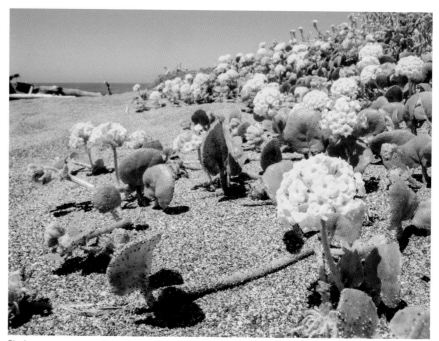

Placing my camera nearly on the sand created an image of sand verbena that accentuates its coastal environment. Pacific coast, Northern California

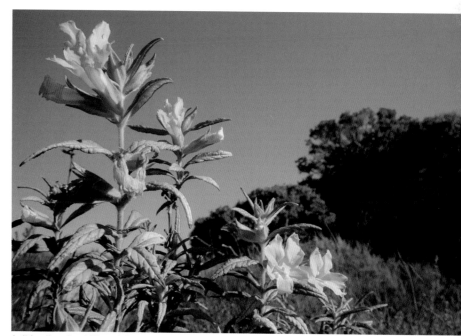

A tilting live-view LCD made it easy to shoot from a low angle to capture the surroundings of these bush monkeyflowers against the sky. Southern California Chaparral

Key Gear

The close-up shot is an important part of flower photography, and many photographers think macro lenses are the only way to do close-ups. While a macro lens is effective, your opportunities are limited if that is your only way to get close-ups.

There are five main ways of getting close-ups: close-focusing lenses, close-up accessory lenses, extension tubes, tele-extenders, and macro lenses.

Highly corrected achromatic close-up lenses attach to the front of your lens. They come in various sizes and can be used on any camera lens with the right filter size.

Close-focusing Lenses (and Cameras)

Today, many lenses focus quite close without added attachments. This is especially true for most zooms on the market. This makes close-up work quite convenient. There are two limitations, however. First, these lenses are often not designed for optimum sharpness up close, so the close-focusing feature only looks its best when the lens is used in the middle range of f/stops (such as f/8 or f/11). Second, they are often set up so that you can only use a certain part of the focal length of the lens, usually either the wide-angle or telephoto end of the zoom.

One nice thing about most small digital cameras is that they usually have a close-focusing feature built into them. These little cameras can be a great way to experiment with shooting flowers since you can try different close-up shots and see each one on the LCD monitor as you go.

Close-up Accessory Lenses

Sometimes called close-up filters, these lenses attach to the front of your camera lens and enable it to focus closer. As long as they fit, they can make any lens focus closer without complications. They can even make a zoom focus close at any focal length.

They come in two types: inexpensive single-element lenses often sold in groups of three, and more expensive multi-element, highly corrected single lenses. The inexpensive close-up lenses are a quick and cost-effective way of getting in close to flowers. However, their image quality can make photos look soft.

The multi-element, highly corrected lenses are often called achromatic close-up lenses. They are available from a number of manufacturers, including Canon and Hoya. These also attach to the front of your camera lens, but offer high quality images. This is somewhat dependent on the quality of the underlying lens, but results can match any other close-up gear.

Extension tubes: I wouldn't be without a set of extension tubes. These are simply empty tubes that fit between your lens and DSLR body, also connecting the two electronically as needed. As you shift a lens farther from the focal plane (where the sensor is), it will focus closer. No optics are involved, so the cost is low. Image quality is excellent, but is still dependent on the quality of the original lens. Some lenses just do better than others for close-up work, regardless of their quality at normal distances.

Extension tubes are very cost-effective tools for getting close-up shots.

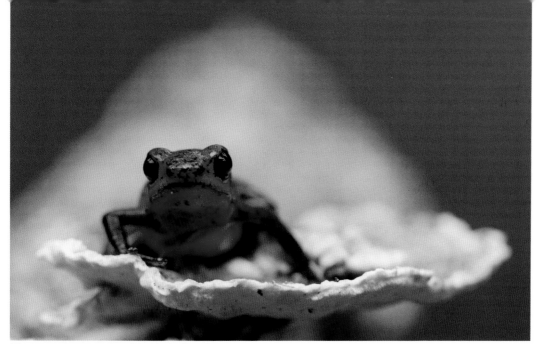

Blue jeans poison arrow frog, Selva Verde, Costa Rica

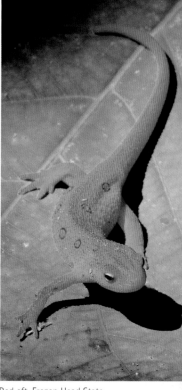

Red eft, Frozen Head State Park, Tennessee

Watch Your Silhouette

The human silhouette is easily recognized by most wildlife. Anything you can do to blend into the surroundings can help. Avoid clothes that contrast with the environment. Camouflage clothing can be a good investment for the serious wildlife photographer, but it isn't a necessity. Khaki clothing, or something similar, can help you blend into many environments.

No matter what you are wearing, it will do you no good if you show your shape against the sky. Plan your approach to your subject so that you do not cross a rise that will put you in silhouette against the sky. It can help to keep a tree or other large object behind you as you move, just to break up your shape. If you do have to go against the sky, keep low and minimize the human silhouette.

Be Aware of Smells

If you want to get closer to a mammal, you need to pay attention to the wind direction and plan your movements so you close in on a mammal from downwind. Birds usually pay little attention to smells.

Keep Quiet

All animals are sensitive to sound. Watch the route to your subject and try to plan it to keep noise to a minimum. Walking through green grass, for example, will get you closer than trying to get through downed branches. If the ground has too much noisy stuff on it, move slowly and watch how you plant your feet. The extra slowness can't hurt the stalking.

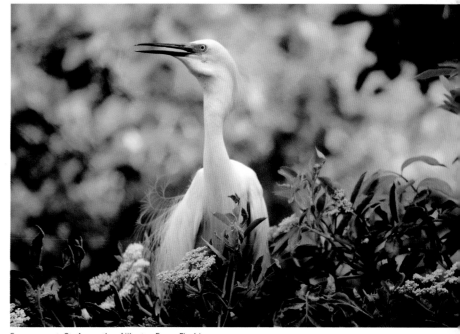

Snowy egret, St. Augustine Alligator Farm, Florida

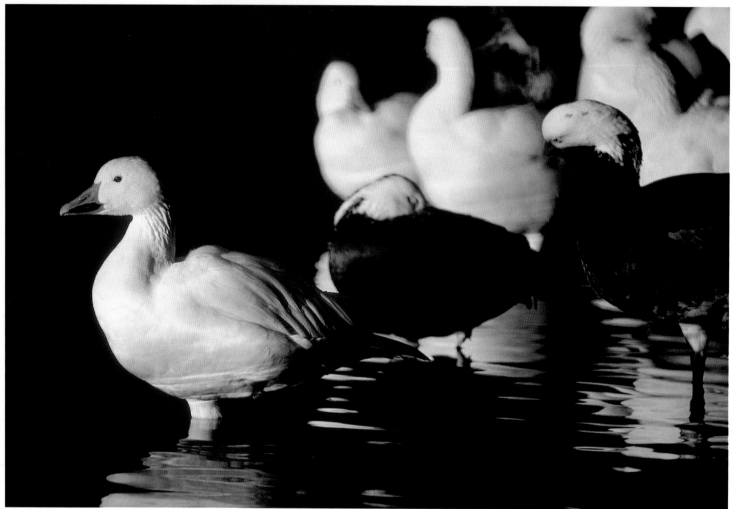

Snow and blue geese, Southern Minnesota

Stillness

As you are actively stalking, you are not keeping still. But often you will find that if you get a certain distance to your subject, then notice that they are aware of you and beginning to act nervous, you can just stop, sit down, and wait. Often the animals will get used to you and relax again.

Boat Stalking

Water animals watch things on shore or below the water, but they don't tend to be bothered as much by slow moving boats, kayaks, and canoes. In general, water animals' flight distances are smaller if you approach them by water. To stalk by water, pay attention to wind and animal movements, and use that to move into photographing position. Move slowly, even using the wind to bring you to the right spot.

Using Blinds

Blinds are a key part of most professional wildlife photographers' work. They are simply something that hides the photographer and gear from view of wildlife. You don't have to be a pro to use blind techniques, and they can be an excellent tool for helping anyone get better wildlife photographs. You can buy a blind for a lot less money than a new lens, and speaking from experience, sitting in a blind while an animal moves close to you is an amazing experience, even if you don't get a great shot.

You can use many things for a blind, from on-location materials to specially made camouflaged tent-blinds. Before looking at options, know the basics of using a blind, because this will affect your choice. Blinds cannot be randomly placed. You need to know where animals congregate and place the blind there. This means doing some

scouting of an area. Blinds can be situated alongside game trails, specific flight paths, and near food and watering holes.

Blinds should be placed so prevailing winds don't blow your scent over animals that could be spooked by smells. They should fit into the landscape as much as possible, allowing animals to get used to them faster.

Existing Materials: Often you can use things that animals are already used to; wood piles, a group of bushes, farm implements, or buildings near feeding areas.

Your Car: In many wildlife refuges, a car is seen as non-threatening and wildlife pay little attention to it. It can help to use a window mount for your camera to be ready to shoot. Be sure to turn off your engine, and do not stop and step out of the car.

Camouflage Fabric: A simple and portable blind is camouflage fabric you can drape over yourself and your camera. You still need to set up near natural objects to block your silhouette. There are special blind coverings that are specially made for photographers and hunters that fit like oversized clothing and roll up for portability.

Tent-like Structures: You can buy a number of tent-like structures that are either made to be blinds or act as them. Blinds usually have zippered or tied windows for gear as well as observation ports. They are often made of camouflage material so that animals get used to them faster. These structures can be wind resistant, so be sure you stake them down. Also, they can be people magnets, so find places where you will not be disturbed.

Permanent Structures: If you have access to a location that is frequented by animals you like to photograph, you could make a permanent blind out of wood. This can be especially helpful in areas where the weather is bad, as the structure can fully protect against wind and rain. There are permanent blinds in many wildlife refuges and nature center areas that are worth checking out.

Wildlife familiar with people and man-made structures will get used to blinds quickly. You may find some animals will

Keep a hillside or heavy brush behind you to get close while camouflaged in a portable blind.

shy off of temporary blinds, such as camouflage cover, if your shape is too different than what they expect at that location. Pros will often build or put up a blind days before they actually plan to use it so that animals get accustomed to it.

Ethics

Wild animals must be treated with respect. Sometimes overexcited photographers will inadvertently harass wildlife, which stresses the animals unnecessarily and makes photographing them harder for everyone. Pay attention to the animals' behaviors. Watch when they get nervous or jumpy. If they keep running from you, back off and leave them alone.

Taking a picture of an animal is not particularly stressful to it as long as you don't press the animal past its comfort zone. You do need to be careful of animals with young and nests. Do not disturb the surroundings of a nest in order to photograph it. Photographers have been known to cut down offending branches and even nearby trees for a better shot, but this opens up the nest to predators. Under no circumstances should either you or the wildlife subject be put into danger. Pay attention to the animal's body language to ensure its safety and your own.

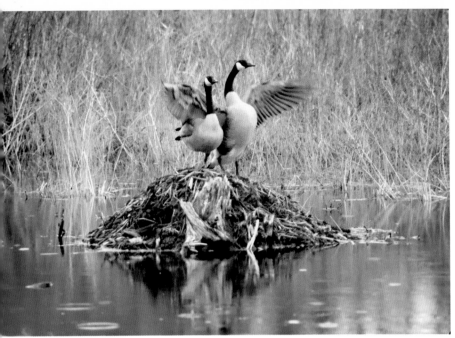

Mated Canadian geese on a muskrat house in Lake Minnetonka, Minnesota

Key Gear

Gaining magnification from a telephoto is a necessity for wildlife photography. There are a number of ways to deal with the necessary gear.

Telephoto Lenses

The physical size of a telephoto lens can strongly affect you and your photography. Compare two 300mm lenses. One is big and heavy, the other light and much smaller. One costs three times the other. The size and price of telephotos comes from the maximum f/stop used. The big and heavy 300mm will be a f/2.8 lens, the lighter model will be f/4. On a long lens, increasing the maximum aperture requires a big increase in glass size. This makes the manufacturing more difficult, too, so the lens goes up dramatically in price.

High speed lenses, like the 300mm f/2.8, used to be more important than they are today for pros. Slow color films in older days meant that you needed every last bit of light in order to get every bit of shutter speed you could. Today's DSLRs have excellent quality at relatively high ISOs (400, 800, and even higher), so you don't

lose a lot by raising the ISO a bit—a setting of 400 allows a 300mm f/5.6 lens to match the shutter speed of an f/2.8 used at ISO 100. This is a real benefit for photographers because it means really fast telephoto lenses, which are always quite expensive, are no longer a necessity.

Telephoto Zooms

Telephoto zooms are an excellent option for the wildlife photographer. They offer a range of focal lengths in a compact package that is easily transported. Image quality is excellent. A zoom can match a single-focal length lens in quality and usability. Many zooms now feature high-quality low-dispersion glass (a technology that really improves the image quality of pictures taken with telephoto focal lengths). Zooms can have one problem: small maximum f/stops. It's not unusual for the wider part of the zoom to have an okay, though not remarkable, maximum f/stop that then shrinks to an f/stop that can make low light work harder as the focal length increases.

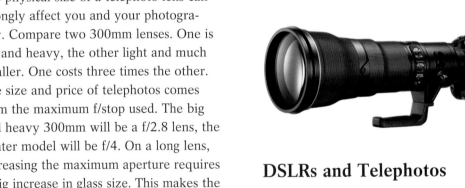

DSLRs and Telephotos

Most DSLRs have a sensor that is smaller than 35mm film. These smaller sensors record a smaller part of the focal length's coverage than a full frame sensor, effectively magnifying the subject in the composition and viewfinder. This is a real benefit for wildlife photography since you can use smaller lenses with shorter focal lengths to get the same magnification effects as you could by using longer lenses with a larger sensor size.

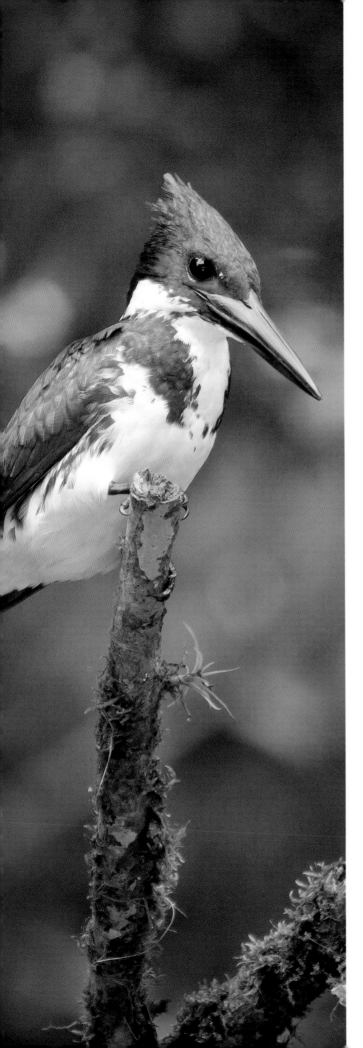

Territories

This chapter actually includes quite a bit about the nature of wildlife since photographing them requires this knowledge. You can drive through the Grand Canyon and step out at any overlook and get a landscape photo of some sort. And if you see an accessible flower, you will have no problems photographing it. Wildlife is a different story. If you want to photograph white-tailed deer, you need to know where they live, how they live, what they eat, and so forth, to be successful.

One aspect of wildlife that I always find fascinating, and that also affects photography, is territory. Animals have very specific territories, or ranges, that they live in, based on a number of factors. These include microclimate conditions, habitat, the influence of man, the distribution of favorite plants, the availability of nesting or birthing areas, and even habits (certain groups of animals will habitually use specific trails and sleep locations, for example).

While all animals have territories that they range through (places they visit through their daily lives), some are extremely territorial and set up very specific boundaries for their living space, defending that space quite dramatically. During breeding and nesting season, birds can be especially territorial. I have had terns and red-winged blackbirds dive-bomb me as I walked along a marsh. You wouldn't think a little bird like a red-winged blackbird could do much, but I still remember such a bird that knocked the hat off of a ranger I knew, then dove again, hitting him on the head and drawing blood! The need to defend territory can be very strong indeed.

This helps anyone who wants to observe animals, however, because even small critters like dragonflies will set up and patrol a territory. Once you find animals in a location, there is a good possibility that you will find them there again (as long as it is not migration time).

Kingfisher, Costa Rica

Close-Up
9

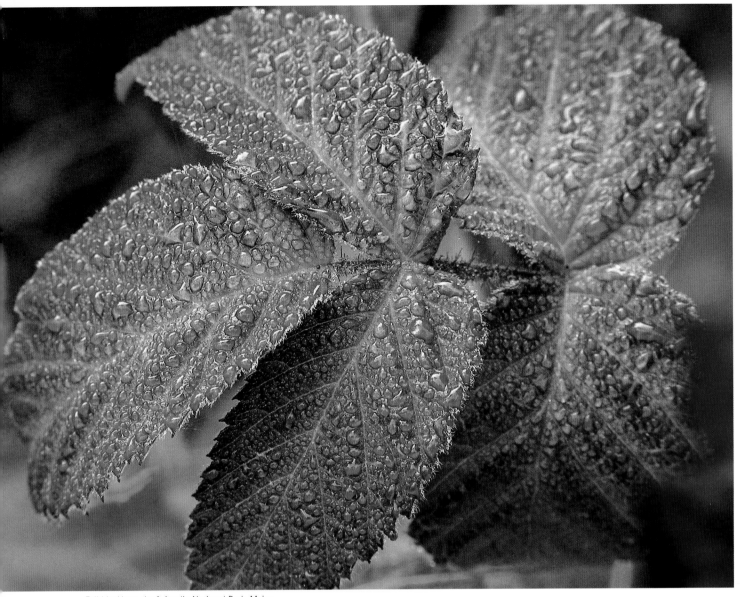

Fall blackberry leaf, Acadia National Park, Maine

Overleaf:
Bush katydid,
Los Angeles,
California

If you really want to explore the magic of nature photography, you have to consider close-up photography. Close-ups let you explore a world of life that is not regularly seen by the average person. Most folks go blithely past such explosions of life in their yards, their gardens, alongside the road, or even in an urban setting. You will find that life in a picture can show images that will surprise and delight viewers just because the subject matter is largely unseen. But this is not the best part of close-ups.

Kodak did research on how photographers took pictures and found that, among the millions of photographs going through photo labs, very few were of subjects photographed closer than two feet from the camera. If nothing else, taking close-ups will give you a set of photographs that will stand out from the crowd, eliciting oohs and aahs without having to travel to far-off, exotic places. But that is still not the best part of close-ups.

Close-up photography is easier than ever. Macro lenses are affordable, almost every zoom lens can focus close, and even the least expensive digital cameras have a close-up setting. But still, this is not the best part of close-ups.

The best part is that, for the lover of nature and photography, close-up photography is always possible, any place, any time, and any season. There are always bits of nature that can be photographed—a weed patch offers amazing colors and forms, a rock outcropping in close focus shows off abstract patterns that could hang in the Museum of Modern Art, a frosty window in the depth of winter brings close-up delight to cabin-fevered northerners, a nocturnal orbweaver spider offers opportunities to test your flash technique while observing a true wonder of nature, and so it goes.

This is truly exciting, because it means nature photography is always possible. You do not need to take weeks off to photograph the bears of Katmai (that's exciting, yes, but not practical for most of us), and you don't have to worry that you can't get to the Grand Canyon or other distant locations (go there, yes, but you don't have to wait until that trip to get great nature photos). Opportunities are yours just for learning to photograph the close-up.

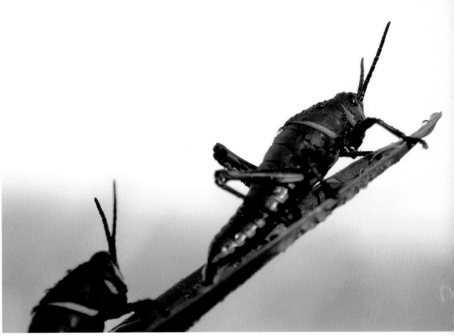

Immature lubber grasshoppers, Loxahatchee National Wildlife Refuge, Florida

New Worlds to Explore

Flowers, wildlife, and landscapes are the big subjects that everyone wants to photograph, but close-ups bring you into contact with new subjects and worlds of nature. This can be exciting in and of itself. Sure, the adrenaline will start flowing if you are near a bull elephant, but most people aren't going to have that opportunity. On the other hand, I can guarantee some excitement if you focus your close-up gear on busy bumblebees working a bed of flowers. If you are allergic to bee stings, you don't want to chance that, but bumblebees will rarely bother a curious photographer. Still, being that close to them will get the adrenaline going.

Close-ups reveal details of worlds that are microcosms of the bigger places we all know. Close in on a carpet of the common haircap moss and you'll see forests and jungles of dense vegetation. Move in on a spider web and you may witness a life-and-death struggle akin to a lion kill on the Serengeti Plain. Magnify a rock surface and you may discover jewels worthy of a king.

These truly are new worlds because you gain access to spaces you cannot physically go. You will see places and events that the average person cannot experience, except through your photography. You can even shoot images of nature that few other photographers have. Millions of people have photographs of the Grand Canyon. A far fewer number have photographed a grasshopper-killing wasp, or the amazing abstracts of crustose lichens. You may not care for these subjects, but there is such an abundance of possibilities with close-up subjects that if you put the close-up gear on your camera and start exploring, I guarantee you will find intriguing compositions and subjects.

Garden daisy, San Diego, California

The Rules Change

Once you start photographing close-up, you will quickly discover things are not quite the same as they are for normal-distance subjects. This is not about finding new worlds and subjects. I am talking about the way photography technically works up close. For some photographers, this is disturbing, throwing their thought processes out of balance. But for others, this is exciting. It reinvigorates their photography. If you open yourself to the changes that occur with shooting close-ups, you will discover that all of your photography is affected, and for the better.

Wild geranium, Eastern Tennessee

Focus

The first thing that changes is focus. Focus is critical up close, and the closer you get, the truer this is. If you photograph a mountain, your actual focus point is "far away" and little else matters. If you capture a waterfall at a moderate distance, you need to be sure the camera is focused on the waterfall, but beyond that, it usually doesn't matter. Focus on a grasshopper up close and personal, and if you miss focus by a fraction of an inch, the photo will change from perfect to a throw-away. If you focus on the stamens of a flower and miss the tips, the photograph will look like a mistake.

We're talking small fractions of an inch. When you are at true macro distances where a tiny subject is filling the viewfinder, even a slight puff of air can knock the subject out of focus in the time it takes between focusing and pressing the shutter. Now, there are some things you can do to help:

1. Take your camera off autofocus (AF)—Autofocus is a tremendous technological achievement and serves photographers very well, indeed, but not in close-up photography. Autofocus will often find the wrong thing to focus on when you are up close. It may have trouble focusing at all on your subject, preferring instead to make things behind your subject sharp (any photographer who has used AF with close-ups will know this by experience). Autofocus will also frequently keep searching for the right thing to lock onto. Manual focus lets you lock the focus on a specific thing.

2. Move your camera to focus—Once you've manually focused to the distance desired, move your camera to and from the subject to get the optimum focus point. You do have to be careful, obviously, because it can cause enough camera movement to make your photo blurry. Still, it is worth the effort because it is so much easier to get the right point in focus this way.

3. Choose your focal point carefully—As you move the camera, watch what goes in and out of focus. Each shift in sharpness will usually change the photo dramatically. It often helps to take multiple exposures, even trying different focal points just to ensure you get something focused right. A digital camera can really help you to be sure you get sharpness where you need it (magnify the image in the LCD).

Monarch caterpillar eating milkweed, Southern California

Depth of Field

Similar to focus changes, depth of field (DOF) also affects what is sharp and unsharp in the close-up. Depth of field is, as discussed earlier, the amount of sharpness from front to back in a photo. However, up close, the amount of sharpness in depth is measured as shallow, shallower, and even more shallow. Depth of field is a distinct challenge.

In addition, most lenses have what is called a diffraction effect that affects sharpness up close. Small lens openings will diffract light, making sharp areas less sharp. This is why most lenses are at their peak sharpness in the middle range of f/stops. Many lenses have a significant drop in sharpness at f/22 and smaller because of this phenomenon—some even exhibit this loss of sharpness at f/16. This is especially evident at wide focal lengths because the f/stop is based on the relationship between the aperture size and focal length, so that small f/stops are physically smaller with shorter (wider) focal lengths. You can shoot with a 50mm lens at f/22, for example, and see a drop in sharpness from a 100mm lens at the same f/stop, though both may be less sharp than f/11 or even f/16.

Macro lenses often show less of this effect, though it doesn't go away. To determine the extent to which diffraction affects your lens, you have to shoot the same subject at f/11, f/16, and f/22, and compare sharpness. In any event, using very small f/stops to get added depth of field may not be an option. Basically, you may have to live with a more limited depth of field in close-ups.

Blood milkweed flower, Los Angeles, California

Light

Light does not really change up close, but how you deal with it definitely does. If you read the flower chapter, you have some ideas on modifying light to get better flower photos. With all close-ups, modifying the light is a key technique, so you can also use those ideas found on pages 75–76. But let's look more specifically at light on the close-up.

Close-ups deal with very small areas, but if you think about that, this means you can easily change the light on those areas. The only way to change the light on a mountain is to shoot at a different time; the only way to change the light on an animal is to be patient and hope it moves. But with close-ups, you can quickly shoot sun or shade, for example, just by the position of your body. That can actually be frustrating when the best angle to your subject means you cast an ugly shadow into the picture.

Here's how to deal with shallow DOF:

1. Be sure of your focus—Go back to the discussion on page 154. Since depth of field is very narrow, you must be sure you have it where you want it.

2. Work the contrast—It can be photographically interesting to contrast your in-focus subject with a distinctly out-of-focus background.

3. Be sure that what should be sharp, is sharp—That means using higher shutter speeds, higher ISO settings, or electronic flash. Soft images due to slow shutter speeds that can't stop camera or subject movement are disappointing. It is better to have something very sharp in a limited area than everything soft all over.

4. Watch the subject plane—If you can, point your camera at the subject so that the critical subject plane (that should be sharp) parallels your camera back. This keeps the prime area of focus on your subject.

Sea urchin shell, Montana de Oro State Park, Los Osos, California

Shallow depth of field shot with the lens wide open gives a unique look to the out-of-focus highlights from sunlight on the dew. Long-leafed pine, Apalachicola area, Florida

The good news is that you don't have to accept the light on your subject if that light causes you problems. The first thing you can do is move your position to change the angle of the light on your subject, changing it quickly from front to side to back light. Also, shift your position to gain a new contrast in the background from the light.

If those actions don't do enough, you can decide to modify the light. Block the sun completely by having someone cast shade on your subject or by putting up anything in the sun's path to your composition. Shade can be a much nicer light on many subjects. You can also put a diffuser into that light path. Anything, from a white shower curtain that is cut to fit your bag to small diffusers made specifically for this purpose, will work. Diffused light is highly effective for many types of close-ups.

White blue-eye grass, Central Mississippi

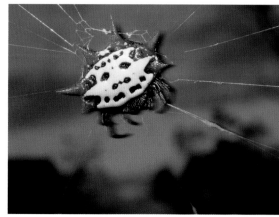

This spiny crab-like orbweaver was shot with flash to create some drama and definition to the spider's body. South Florida

Try adding your own light. In a forest, this is as simple as using a reflector to redirect sunlight onto your subject. In any situation, adding light may mean using a portable flash. Flash is a very important addition to any close-up photographer's gear because it is a controllable light than can be moved anywhere with the right cords and accessories, allowing it to become front, side, or back light in an instant. It is easily diffused or reflected to change the quality of the light.

Flash gives another great advantage to close-up photographers because it results in sharp photos. There are several reasons for this: first, flash has an extremely short duration in the thousandths or ten thousandths of a second, stopping any camera movement; and second, flash up close is almost always powerful enough to let you use any f/stop you want.

Flash is consistent. Once you set up a close-up flash system, you can count on it delivering the same results again and again. This can be a great advantage for certain subjects, especially insects that are constantly moving. On the other hand, that consistency can be a problem when photos taken with a flash system look monotonously the same, photo after photo. This can be avoided with systems that allow you to change the position of the flash or flash heads.

Flash does have disadvantages. The light is not natural, which means the existing light conditions, good or bad, will be lost. Flash also falls off quickly so that a close-up subject can be perfect in exposure, but the background dead black. Finally, flash systems can be heavy, bulky, and awkward to handle in the field, especially if they unbalance the camera.

Close-up Subjects

Flower Details

Let's look at specific close-up subjects and how you might work with them. We went into some detail on flowers as a specific and popular subject in Chapter 7. But it can be fun to go beyond photographing flowers as whole flowers. By getting really close, you can focus on incredible details, structures, and patterns that most people miss.

In addition, we all know flowers can have amazing color. On a purely scientific level, these colors have evolved to attract insects. But for us, the colors are far more than bug magnets. Look close into a bright flower and you can almost feel the color. It becomes a sensuous experience.

You can capture this experience in an image, but you can't do it by approaching flower photography conventionally. The way to do it is to use your camera's close-up capabilities and get right into the flowers. Use a wide lens opening, like f/2.8 or f/4, and start shooting literally right through the flowers with this limited depth of field. A telephoto focal length can increase the effect.

This technique turns the flowers closest to your lens into beautiful swaths of out-of-focus color. Find something interesting to focus on, but let everything else go soft. You have to experiment by moving around and having your lens look through different groups of flowers. You will start seeing all sorts of color forms and shapes contrasted with the sharp part of your photo.

These photos are a lot of fun to do. They become pictures of color, not the flower. You can be as realistic or abstract as you want—it largely depends on what you have in focus. You can find a complete flower for the focus point and surround it with color, or you can forget that amount of realism and just go for maximum color effect.

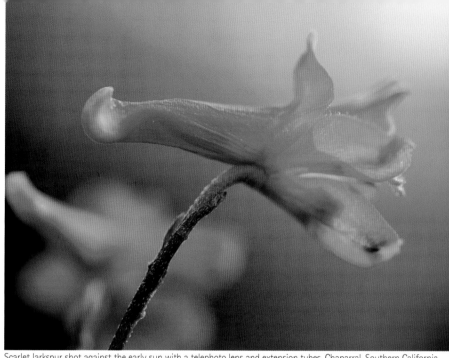

Scarlet larkspur shot against the early sun with a telephoto lens and extension tubes, Chaparral, Southern California

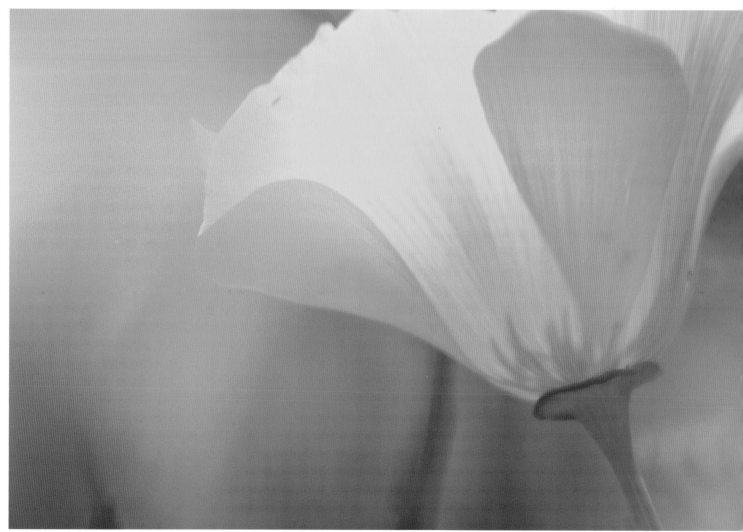

California poppy, Los Angeles, California

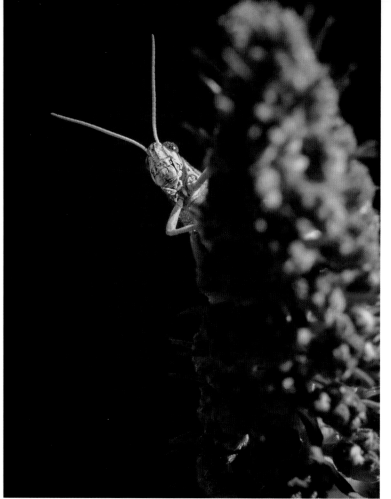

Bugs: Drama, Action, and Hollywood Effects

Many people are uncomfortable with insects, and even the most serious, all-nature-loving photographer has to have some sympathy for that. A few insects bite, several transmit diseases, and the idea of one crawling on your skin can give almost anyone the shivers.

Yet, very few insects actually cause problems, and they are hugely important to the natural world and human life. There are more species of insects than all other animals combined. They are key parts of every ecosystem on our planet. Without insects, most flowers would no longer exist because they would not be pollinated and produce seeds. A huge number of birds would cease to exist without their food source. Without insects, we would have no honey or fruit.

Dramatic sun and shade create a unique image of a gray bird grasshopper. Los Angeles, California

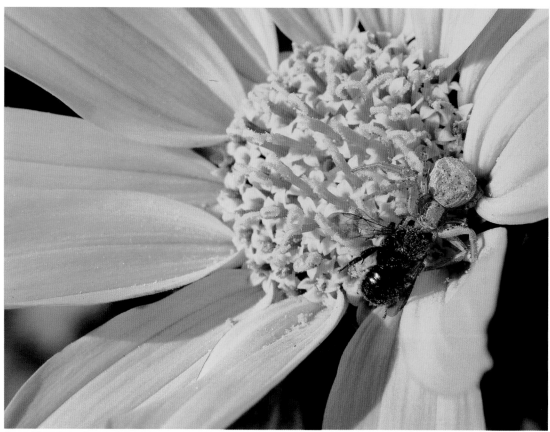

A true life-and-death struggle is seen up close as a crab spider eats a bee. Grand Teton National Park, Wyoming

No matter how you feel about insects and their relatives, they offer some of the most dramatic, action-filled nature photography that can be found anywhere, plus you get to see creatures up close and personal with amazing shapes, colors, and designs that even Hollywood's aliens cannot match. Insect photography offers a sense of adventure and contact with truly wild creatures.

Insects are amazing photographic subjects. Butterflies show beautiful colors and shapes, dragonflies are like flying jewels, ladybird beetles (ladybugs) are a joy to discover, cicadas stun us with their life cycles, caterpillars offer wonderful, slow-moving subjects, and the list goes on.

Insect relatives are great subjects, too. Spider webs are architectural and engineering feats, and many spiders have color patterns and shapes that absolutely amaze people when they take time to observe.

Much of what we discussed about photographing wildlife applies, believe it or not, to insects. Plus there are other things that apply primarily to the little critters.

Here are some things to consider when photographing insects:

1. The need for magnification—Bugs don't always let you get close, so having a telephoto with extension tubes or a macro telephoto lens can be a great help.

2. Location, location, location—Not just a mantra for real estate, this thought will help you find insects. While they do "live everywhere," they tend to be more highly concentrated in certain locations. Like all animals, insects need food and shelter. Any place that has different kinds of plants will have many kinds of insects. Flowers are a great place to look for insects. There will be insects feeding on the leaves, pollen, nectar, and other insects.

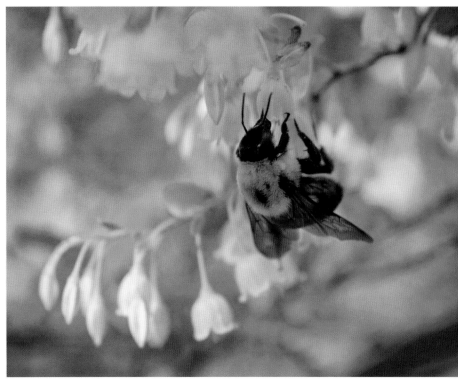

Bumblebee on huckleberry flowers, Apalachicola area, Florida

3. Silhouette—A person silhouetted against the sky spooks insects as well as wildlife. While only a few insects have really outstanding eyesight, almost all have an excellent ability to discern a moving shape against the sky. Watch your back to see what you are contrasting with.

4. Movement—There is no animal of any kind that associates rapid movement with safety. Move quickly and you are like a predator—the bugs will leave. Many insects are very sensitive to movement, so move slowly and deliberately.

5. Vibration—Insects and their kin, as a whole, are very attune to vibrations. They sense heavy footfalls on bouncy soil (this can be transmitted through plants) and will often bolt the instant they feel a bump. You have to be careful how you move into position, making sure not to bump things.

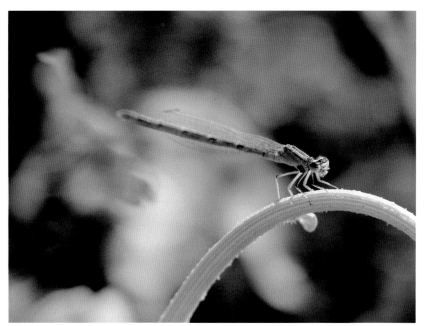

Damselfly, Central Missouri

6. Flight distance—Insects that have good vision have a definite flight distance. They act the same as wildlife, getting nervous as you approach, then flying, hiding, or dropping to the ground and looking for shelter. You can affect this distance by how you move in toward the bug.

7. Time of day—Since insects are basically the same temperature as the air (with some exceptions), they are most active in warmer weather. Really active bugs on a warm summer day can be very frustrating to photograph. Early morning is a great time to photograph insects and their kin. Lower temperatures and dew on them and their surroundings will slow them down.

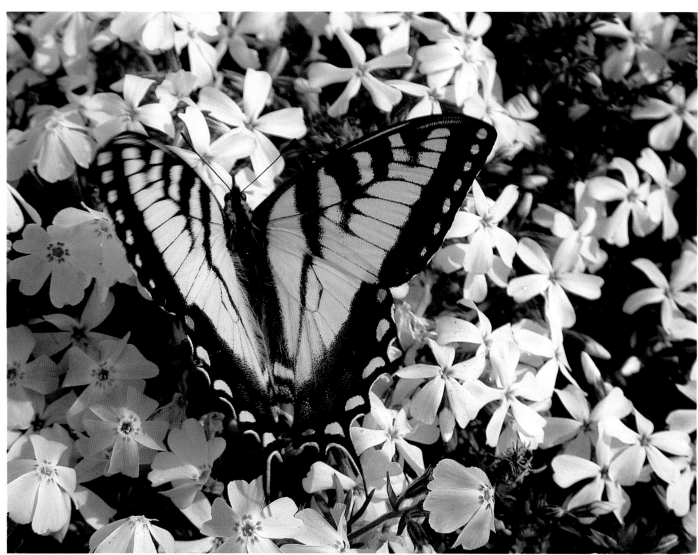

Tiger swallowtail on creeping phlox, Western North Carolina

Moss and Lichens

Moss and lichens are two entirely different sorts of organisms, even though they get mixed up (reindeer moss is actually a lichen). Both have growth forms that fit them tight against rocks as well as loose-growing ground structures that can rise several inches high. They grow from the ground to the tops of trees and from deserts to mountaintops.

Moss is a primitive plant, always some shade of green, and favors moister conditions than the lichens. Lichens are a combination organism made up of a fungus and algae, and are technically no longer considered part of the plant kingdom. (Biologists gave up the two-tier kingdom idea of just plants and animals long ago.) Lichens can live in deserts and can be found in a great variety of colors, though they are mostly gray, gray-green, orange, and red.

So why photograph them? Get to their level with a close-focusing lens, and you'll quickly see why. Mosses and lichens grab hold of your compositional senses and keep you looking as you record photograph after photograph. Mosses are incredibly textured carpets offering great opportunities for photographs that emphasize design. Other mosses will remind you of jungle forests when you get close, though the perspective is quite a bit different because of limited depth of field.

Lichens, on the other hand, give you amazing abstract patterns when you find the crustose varieties growing on rocks and trees (these grow like a hard crust with no height). Sidelight is ideal for shooting lichens. Foliose types (leaf-like) stay close to their substrate, offering a whole different set of radiating patterns if you look closely.

Probably the most spectacular lichens for the photographer are the fruticose type. These have long stems that lift the "plant" body well above the ground or rocks where they live. They have excellent shapes and forms that are well worth examining close-up. Reindeer moss is a fruticose lichen, and has wonderful mounds of blue-gray growth. Another is the British soldier lichen, with its red fruiting bodies lifted high on gray stalks.

Crusticose lichen on rocks, Arches National Park, Utah

Water is very important for these organisms, even for the lichens in the desert. Water brings both mosses and lichens to life, enriching the moss greens, livening up the lichen colors of orange, red, and others. For some, constant water and humidity is critical, which is why mosses grow so well in temperate rain forests or near waterfalls, though some lichens need humid conditions, too (especially the hair-like versions that hang from trees along the west coast).

Moss and lichens don't move much from the wind, making them perfect for using a tripod. It is ideal for your tripod to have a removable center column, as you can position your camera right down to the ground. This makes shooting at smaller f/stops and very slow shutter speeds no problem.

Rock detail, Death Valley National Park, California

A rock erosion pattern in sandstone. Santa Monica Mountains, California

Shell fossil, Santa Monica Mountains, California

Rocks, Shells, and Other Hard Nature Objects

Rocks, shells, bark, fossils, and more are often at their very best when examined up close, making them ideal subjects for close-up photography. These subjects make great photographs when you concentrate on textures and patterns.

Texture is mainly affected by light. Sidelight will always make texture pop. Strong textures will take away from color patterns, so you don't always want sidelight. It works well when appropriate, but can be distracting if you want to see the colors.

Patterns are a compositional concern. Photographing the patterns on these subjects is easy. But patterns alone can be boring. It is helpful to include something that contrasts with the pattern and gives your eye something to relate to. What that contrast is will depend entirely on your subject and its surroundings. There is a very famous photograph by Eliot Porter of a pattern of clamshells near the ocean in Maine where wild rose petals have fallen—it offers a great color and textural contrast.

Here are some ideas to get you started. If you look around, you will always find ways to break up a pattern and get a better composition.

• Find a section of the pattern that deviates from the rest, such as a rock detail that includes a place where the rock form shifted.

• Look for a color that contrasts, such as a fall leaf on the bark of a tree.

• Use size contrast, such as a large shell among many small ones.

• Find movement in the composition that contrasts with the pattern, such as a vein in a rock that has an angle against the texture of the rest of the rock.

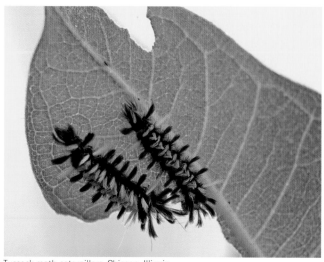
Tussock moth caterpillars, Chicago, Illinois

Key Gear

In Chapter 7, we discussed ideas for close-up photography, including a complete rundown on the gear you can use. Refer back to pages 128–129 for specifics on close-up gear, especially as everything said there applies to this chapter.

Flash

When you add flash to your close-up gear, you extend your possibilities dramatically. Flash was once intimidating, but with automatic through-the-lens (TTL) systems, flash is a valuable part of every nature photographer's close-up kit. You can use any built-in flash to start.

For more power and control, you need a separate, external flash unit plus a dedicated flash cord. The cord is a simple accessory—just a connection between camera and flash that allows both to communicate to each other for proper exposure and more. With this cord, you can hold the flash at different positions relative to your subject. You can move it left, right, top, and bottom, giving your close-up a different look each time.

Another advantage of a corded flash is that you can apply a technique called "feathering." Sometimes your flash may be too strong, so instead of pointing it directly at the subject, point it a little off from the subject so only the edge of the light hits it. You can also point the flash completely away from the subject to brighten a background and not affect the subject.

When buying an accessory flash for close-ups, you do not need the biggest, most powerful flash because it will generally be very close to the subject. You can often get away with a compact, easily carried unit that is also less expensive. On the other hand, it is true that the biggest, most powerful flash for a given camera is often the one with the most features. If you need a certain feature, such as a swivel head for indoor use, be sure the flash you are considering has it. A powerful flash can offer you additional capabilities for filling in dark shadows in other types of nature photography, if that is important to you.

Wireless capabilities for flash are extremely useful. These allow you to set off a flash that is not connected to your camera (though you will need a camera-connected flash as a controller, even if it is built-in). With a wireless remote flash, you can put the unit anywhere in relation to your subject without worrying if a cord is in the way. You can also usually use more than one flash, giving you the chance to have a backlight and a fill light or a main light and a background light on your subject.

Ring flash and twin flash units fit around your lens to get the light very close to the subject. While ring flashes are popular with

dentists and fashion photographers (strange, but true), they are a little too flat in their light, for my taste, in close-ups since the light comes from around the lens as a direct, frontal light. Twin flashes use two small, repositionable units on a ring attachment around the lens. They can be moved for best light and their intensity varied to allow better light on the subject.

Telephoto Lenses

A telephoto lens magnifies your subject at a distance, letting you get close-ups without having to move physically close to the subject. This can be important if the subject is flighty, if it bites or stings, or if you keep shading your subject because your lens and camera are so close to it. If you find you often experience these challenges, you might look into a telephoto macro lens. Otherwise, a set of extension tubes is probably the best accessory to have since these tubes will let any telephoto or zoom lens focus closer. An achromatic close-up lens sized for your telephoto or zoom can also get quality close-ups.

Wide-angle Lenses

Most photographers don't think of wide-angles for close-up work. Years ago, there were wide-angle macro lenses, but they haven't been on the market for a long time. Wide-angle lenses change your perspective and depth of field as described earlier. You can get amazing shots of close-up subjects

with a wide-angle focal length. Use a short extension tube with a wide-angle lens or zoom to help it focus closer (even moderate-sized extension tubes rarely work). There are a few wide-angle lenses that focus close normally. A very easy way to make wide-angle close-ups is to use a compact digital camera. These cameras often have close-focusing settings that only work with the wide-angle part of their zooms, plus many allow the use of achromatic close-up lenses that give high-quality results at any focal length.

Hint: Aiming your flash at your subject can be a challenge. You can solve this by using a special flash bracket to hold your flash in position (most camera stores have them, or search the Web), by having a companion hold it for you, or by simply handholding it. Put your index finger on top of the flash. Point your finger at the subject and the flash is pointed there, too.

10 Quick Tips for Great Close-Up Photos

1. Try a beanbag—Beanbags are a great way to support a camera when you need to get it low, such as photographing moss on the ground. You can get small ones that easily fit in your camera bag. Push the camera into the beanbag's softness for support and minimal movement.

2. Close-up seeing—Many years ago I had a workshop with the great photographer, Ernst Haas. He gave us a tremendous exercise to better see the photo possibilities around us. Go to a spot of nature—a garden, an empty lot, or a park—and arbitrarily pick a small area (20 x 20 feet is good). Spend an hour there finding close-ups. Most people get bored after about ten minutes, but then are forced to look and find that in reality, one hour just gets them started.

3. Use a polarizer for rocks—Rock colors and patterns can be easily diminished by sky reflections that dull the rock—you won't actually see sky reflected except for the color. A polarizing filter will allow you to remove those reflections. Put it on and rotate it until the colors of the rock look their best.

4. Use a round-the-lens reflector—Take a piece of white cardboard and cut a hole exactly the size of your lens. Put this over your lens when you shoot backlit close-ups. The white cardboard will act as a reflector, kicking light into the shadows. You can also buy these types of reflectors.

5. Use your hand as a clamp—Since close-ups mean you are getting so close to your subject that the area seen by the camera is small, it is easy to use your hand to grab a wind-blown flower to steady it or pull it into focus and not see your hand in the photo. You can also purchase specially made flower clamps that attach to your tripod.

6. Use a waist-level finder—You can purchase a waist-level finder for most DSLRs that will allow you to get your camera lower to the ground without having to smash your face into the soil. Another option is to use a DSLR or a high-quality, compact digital zoom camera that has a swivel LCD. These allow you to shoot from all angles and still see what the lens sees.

7. Temper your built-in flash—To use a built-in camera flash for close-ups, you need to temper it. Few cameras are set up to give a good exposure for flash when used at very close-focusing distances, and the flash itself may be aimed poorly for such use. Put any kind of diffusing material over the flash to cut its light and make the light better for close-ups. You can use a piece of white cloth, translucent plastic, or even natural materials (I once used a cluster of white flowers).

8. Use continuous shooting for better focus—If your subject moves, you may find it difficult to get the precise focus you need. Put your camera on continuous shooting and hold the shutter down for a burst of shots as you work to find focus. You will almost always find that at least one of these shots will be perfectly focused.

9. Balance your flash—If your flash completely overpowers the existing light, the photo may be dramatic, but the shadows may be too dark and the background black. Choose a camera setting that will balance your flash to the existing light so that some of the light from the sky, for example, will fill in the shadows. Unfortunately, camera manufacturers have not chosen a consistent way of doing this, so you will have to check your manual for more information.

10. Corral your insect subject—Use the sensitivity of insects to your advantage when an insect moves away from you to the other side of a stem. Reach out and move a hand over there, or have a companion move to that side, and the insect will usually move over to where you are.

Little Stuff

The big stuff in nature is really what catches our attention first. A spider's web is a pretty impressive architectural feat, but put it in Yosemite, and it won't be what makes everyone stop and take notice. A bumblebee always looks like it defies the laws of gravity when it flies, yet a hawk riding up air currents as it migrates along Lake Superior will actually gather a crowd. A carpenter bee is a fascinating and important part of life in the Great Smokies, but it will be ignored when a black bear is spotted down the trail.

Yet on every level, it is the small stuff that really makes nature function. According to Piotr Naskrecki, author/photographer of the marvelous book, *The Smaller Majority*, 99% of all animal life visible to the naked eye is made up of creatures smaller, on average, than a human finger. It has been estimated that there may be 20 – 30 million distinct species of arthropods (creatures without backbones including insects, spiders, and centipedes) in the world, and 10 quintillion insects (this is 10 with 18 zeros behind it) are alive at any given time. This is an amazing amount of life that is always around us, ready to be recognized and appreciated for its contribution to the world.

One reason they do so well is because they are small. In a single tree, you can find dozens of species (perhaps hundreds in the tropics) because they fill in the very small microclimates, from the dark, damp soil around the tree roots, to the protected cavities in the bark, to the wind-blown and exposed leaves at the top of a tree.

How do these little creatures contribute? Our world is made up of very intricate systems of deeply inter-related and interconnected elements that start with energy from the sun. These systems are so tightly structured that even the most advanced computers cannot mimic them. We can see all the little pieces, from mosquitoes to bats, but we only see glimpses of how they all fit together. If a little critter is a keystone of a local habitat, we might not recognize that until it is gone and the habitat deteriorates.

The little things in our world tend to be overlooked by people who want to exploit nature, yet they are exceptionally important in the overall scheme of things. I don't believe that life on our planet is random. It is connected in complex ways that are not fully comprehended by man.

Ladybird beetle feeding on aphids, Shenandoah National Park, Virginia

Special Techniques
10

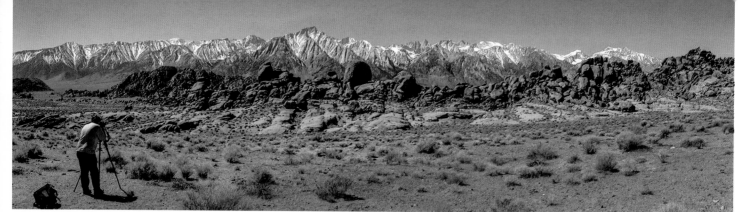

Panorama of Alabama Hills and Eastern Sierras, California

Infrared photo of hillside in central California, with live oaks and willow foliage in foreground

Black-and-white of giant Coreopsis flowers, Point Mugu State Park, California

Photography is part art and part science and technology. Since the beginning, pushing the technology to make the art better has been a constant part of the craft. Today is no different, as digital photography continues to offer new approaches to old techniques, resulting in new possibilities for all types of images, not just nature photography.

This chapter covers three special photographic techniques that are a great benefit for the nature photographer and can further his or her quest to capture the magic of nature in a picture. These are not new techniques, nor are they esoteric techniques that only a few can deal with. In fact, two of them have been with photography since the beginning.

What puts black-and-white, panoramic, and infrared photography (IR) into the special-techniques chapter is that they are not the everyday practices most commonly used to photograph nature. Black-and-white photography, once the only way to photograph, was dominant until the 1970s. It nearly disappeared in the 1980s and 1990s when everyone was shooting color. It has staged a renaissance and is now seen as an interesting and artful specialty.

Panoramic photography has been around, believe it or not, almost since the beginning of photography. Many people think multi-shot panoramas are new because of digital techniques, yet early photographers from the 1850s had already made such images in their darkrooms, though digital has made it easier to do. Panoramas are a great way of photographing nature.

Infrared photography has long held a special fascination with nature photographers "in the know," but was always difficult, especially when shooting film. A curious side effect of digital photography has been true infrared photography. It is curious because digital camera sensors are inherently sensitive to infrared, but digital camera engineers and designers usually try to remove this sensitivity. When photographers discovered that infrared could work beautifully with digital, they started seeking to customize their cameras by having the IR-blocking filters removed.

Overleaf: White Sands National Monument, New Mexico

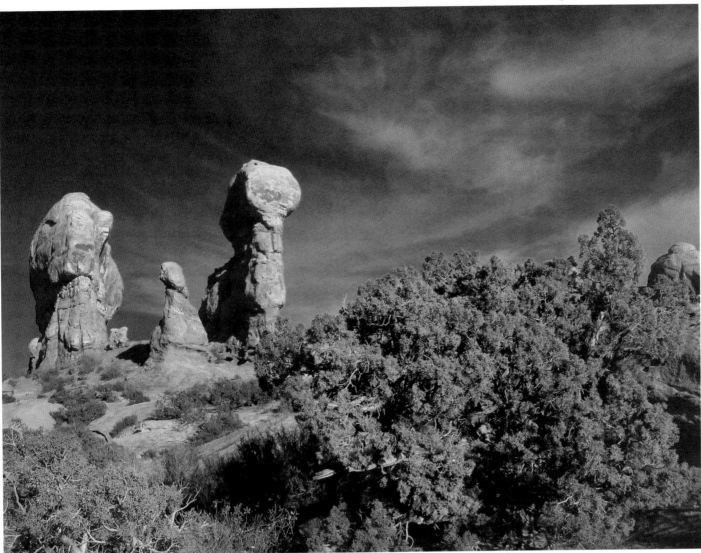

Rock formations and junipers in Arches National Park, Utah

Getting the Most from Black-and-White Photography

1. Watch the light—No matter what your subject is, no matter how dramatic it seems in person, it is the light that will make it or break it as a black-and-white photograph. Look for the angle or time of day that the light does interesting things to your subject's tonalities.

2. Look for contrast—Colors are not your friend when shooting black-and-white images. Look for contrast, which is separate from color, in brightness and tones.

3. Expose for shadows and midtones—Black-and-white images generally look their best when you can see good detail in the midtones and something other than a black hole in the dark shadows. Underexposure, as a rule, is detrimental to good black-and-white photos.

4. Look for the dramatic—You don't have to have dramatic contrasts and shapes in every black-and-white photo you take, but black-and-white images respond so well to such drama that you should be regularly looking for it.

5. Try photographing the shadows—Shadows can be great subjects in and of themselves. Look for scenes that have strong shadow shapes that can be plainly seen against something simple that enhances, not competes with, the shadows.

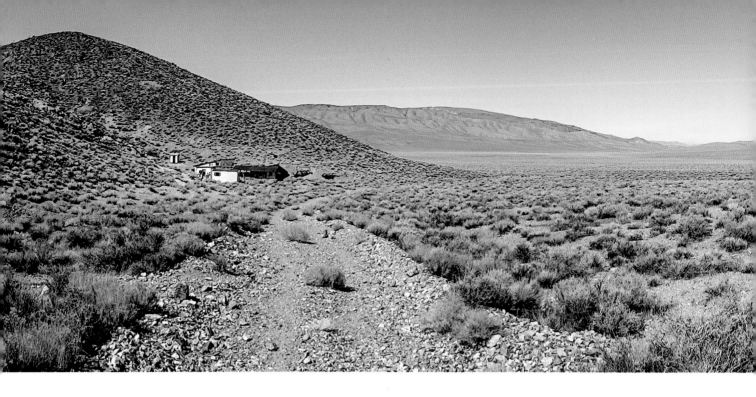

The Really Big Scene

Panoramic images have fascinated photographers and viewers since photography began. The earliest photographers shot multiple images across a scene and either blended them together in the darkroom or printed the shots separately, overlapped them, and pasted them together into a panoramic collage. Later, big panoramic cameras were developed that took very wide photos onto a long roll of film.

Today, you can take multiple standard photographs across a wide scene and combine them (stitching) using an image-editing program to produce a panorama. You can also crop a standard photograph into a panoramic format. This works especially well with large-sensor, high-megapixel cameras that can take the cropping without losing too much quality.

Note: Panoramas can be shot in both horizontal and vertical formats, but most are "wide-scene" photos.

A third way is to create panoramic images in-camera. Sony offers a feature called a "sweep pan" with many of their cameras, from small point-and-shoots to DSLRs. You literally sweep the camera across a scene as it takes multiple images. The camera then internally stitches the images together into a finished panoramic photo. You now have a finished image without any further processing.

Composing a Panorama

Panoramic images require a different approach to the scene than a standard photograph. This is a whole new way of seeing. Simply putting a scene composed for a standard image into a wide composition never works. Such a photo looks just like a regular scene surrounded by too much space.

The first thing you have to do is see the scene in front of you as a strong horizontal or vertical composition. Most panoramas are horizontals, but verticals can be compelling, too. Think of tall trees or waterfalls, for example.

Single-shot Method Using Panoramic Crop or Sweep Pan

Advantages

- Only need to take one shot to produce a panoramic photo

- No stitching or special processing is required in the computer; only cropping if needed

- Action can be easily photographed (though not with sweep pan)

- Panoramic composition can be seen in the LCD

Disadvantages

- High-megapixel cameras can be expensive as well as large and heavy

- Cropping means less quality because you are removing pixels

- Sweep pan doesn't work with all situations, and focal length options may be limited

Multiple-shot Computer-processing Technique

Advantages

- Any camera can be used, not just high-resolution DSLRs

- Easy to do; many point-and-shoot cameras even include panoramic aids

- Can set the lens to nearly any focal length to shoot the images for panorama

Disadvantages

- It can be hard to see a wide-area composition as you are building it in steps

- You should use a tripod and be sure to line up shots

- Shooting at oblique angles (up or down) to a horizontal scene can be difficult because the images will not go together easily

- Action is difficult to capture because the scene must be photographed in multiple shots

- Images are put together in the computer (though there have been a very few cameras designed with this capability built into the camera itself)

Examine the scene for its potential. You have to imagine a multi-shot panorama put together. Can you eliminate the nonessential elements above and below the horizontal area of interest and not have the scene suffer? What do you see to the right or left of a vertical composition? This is very important to consider, as many scenes have essential elements that can't be cut off.

For horizontals, you need a composition with something interesting and important at the left, then additional elements all along the scene until you reach the right side of the composition, which should have another visually important element. Apply the same reasoning to a vertical. Many panoramic images fail because there is simply not enough interest throughout the composition. This doesn't mean there has to be drama throughout—good color, interesting graphic elements, or anything that keeps the eye engaged and moving across the scene is good.

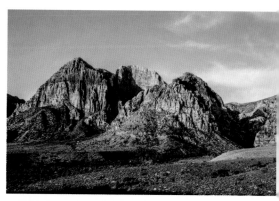

Multi-shot Panoramas

Those who are purists when it comes to shooting panoramas are extremely careful in how they set up the camera for a multi-shot image. There is no question that such an effort does make for images that go together better when stitching. Don't let that keep you from the magic of panoramic shooting (because it is magic). You can get good results even from casual image capturing. However, here are the basic steps for getting good panoramas from multi-image capture with a digital camera.

1. Use a tripod—While it is possible to shoot panoramas without one, a tripod helps in keeping the separate images aligned, and it will help you see your composition better.

2. Level your tripod and camera—If you shoot at an angle to your scene, the images you shoot will be hard to combine in the computer. Use a level if you can.

3. Plan your composition—Decide on the composition—which elements will you choose to include from the left and right or top and bottom of your image?

4. Use manual settings—Set both exposure and white balance to specific settings. Don't use autoexposure or auto white balance. You need the individual shots to match, but autoexposure and white balance will tend to put variations into the shots. Don't use a polarizing filter, either, because it polarizes a wide scene unevenly.

5. Shoot overlapping shots—Use 30–50% of the image for overlap, whether shooting horizontally or vertically.

This panoramic image of Red Rock Canyon Conservation Area outside of Las Vegas, Nevada, was originally created from a series of four images shot across the scene with sufficient overlap between them.

6. Bracket—If you need to bracket, bracket whole sequences, not individual shots.

Once you have recorded the multiple images for the panorama, you need to stitch them together using an image-processing program. The easiest way to do this is to use the automated functions of Photoshop or Photoshop Elements. With these programs, you simply select which images to use for the panoramic photo, then let the software do its job in stitching them together. The latest versions of both Photoshop and Photoshop Elements do a superb job of putting these multi-image panoramic photos together. Getting good results, however, depends on paying attention to how you shoot the photos in the first place, as described above.

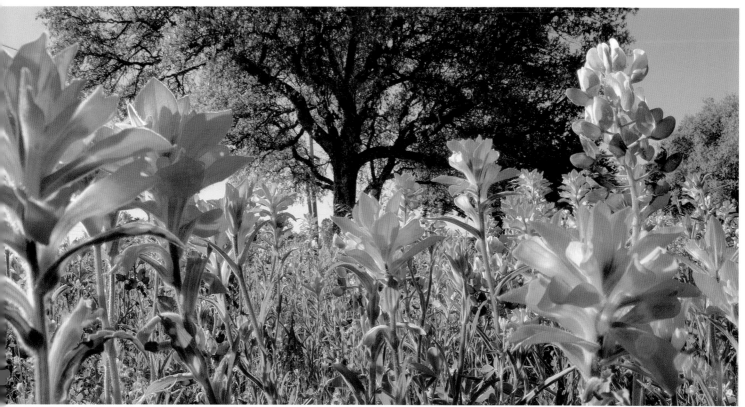

Cropping an image so its width is proportionally much greater than its height is one way to create a horizontal panorama-like photo. Texas Hill Country

Getting the Most from Panoramas

1. Look for strong horizontal lines—A strong horizon or other horizontal line that cuts across your image can integrate it visually; this is an easy way to get a good panoramic composition. If you are shooting a vertical, look for a strong vertical line.

2. Be wary of polarizing filters—The polarizer is a great filter for landscape photography, but usually not for panoramas. This is because the sky is cannot be polarized in such a way that the color and tonality stays consistent across a panoramic scene.

3. Compose from the outside in—Look at the outer parts of your scene first, not the center, as you compose the panoramic image. This goes against the way most people start their compositions. However, it can really help ensure that your panoramic composition has interesting elements at the outside edges.

4. Use space—Space is not the same as empty places in a composition. Space can be an important creative element for a photograph if you look for it. A good example of this would be if you created a composition with a striking tree at the left side, then a big expanse of blue sky (the space) through the middle and right side of the photo.

5. Beware of autofocus—When shooting a multi-shot panoramic, you may find that your camera autofocuses in the wrong places on some of the shots, ruining the effect. Either turn off the autofocus or be very aware of where the camera is focusing for each shot.

Infrared Digital Photography

Years ago, many photo enthusiasts experimented with infrared black-and-white photography and discovered they loved the results but hated the process. Shooting with infrared film was a pain. You had to load it in the camera in a darkened room, check your camera for infrared leaks (which even perfectly good cameras often have), use a pitch-black filter that you could not see through, guess on exposure, unload the camera in a darkened room, and have it specially processed.

The results were very interesting once you got them back, though. Vegetation turned white, skies were black, shadows were very dark in tone, haze disappeared from the scene, and new visions of the world were revealed. But it wasn't worth the effort for most photographers. A few even tried color infrared, but the results were too weird for most, making the effort even less inviting.

Digital changed all this. At first, photographers had no idea that the image sensors in digital cameras were sensitive to infrared light, but soon enough some tried infrared shooting and discovered that a digital camera gave true infrared photographs without the problems of film. In addition, they could instantly see results, so exposure and composition could be corrected on the spot. This opened new avenues for nature photographers. It became easy and instantaneous to duplicate the exotic, rarely used infrared film results.

White leaves and dark sky produce a stark contrast in this IR photo of a cottonwood tree near Moab, Utah.

Shooting Infrared

While all digital camera sensors are sensitive to infrared, you can't use all digital cameras for infrared shooting. This is because camera manufacturers put filters between the lens and sensor to block infrared light to improve certain image quality parameters for standard photos. The strength of these filters depends on the particular camera model.

You can check very simply to see if your camera will record infrared. Point a remote control at the camera, push a button on the remote, and see if the light from the remote can be recorded on your DSLR (or if it appears in the LCD of a compact digital camera or DSLR with Live View).

If you still own a digital camera that has been replaced with a newer and/or updated model, you might be able to put it to use shooting infrared photography. There are a number of companies who will modify digital cameras by removing the infrared filter to allow these cameras to capture infrared light. LifePixel.com is probably the best known for this and has a good reputation with digital IR enthusiasts.

Getting the Most from Infrared

1. Watch the direction of the sun—The strongest infrared effects come when the subject is reflecting this light directly back at you from the sun. This is why most infrared photos are shot with front light.

2. Look for bright green trees—These strongly reflect infrared light and record as a dramatic white color. They can really make an infrared photo snap with life.

3. Avoid infrared shooting on heavily overcast days—You won't get much infrared light bouncing around on cloudy days and the image will generally look just like a dull black-and-white photo.

4. Try it on hazy days—Infrared effects are not as strong on hazy days, either, but infrared shooting can give you an advantage because it cuts through the haze. It can make the scene look much less hazy than what you saw in the visible spectrum.

5. Look for blue skies with clouds—You get very strong contrasts between clouds and sky with infrared. This is a very dramatic look and can be worth including in many scenic infrared shots.

6. Process your digital infrared images in your computer—Because digital cameras are not optimized for infrared capture (even though they do it), images will often lack the tonalities that they need. Use your image processing software to be sure the blacks are black, the whites white, and contrast looks good.

A classically ethereal atmosphere is evident in this IR image of willows in central California.

Visible and Invisible

Though human vision is extremely good, our perception misses many aspects of the natural world that are important to our wild neighbors who share the earth. Since we do not have the eyes of a cat or a bee, we cannot know exactly what they see, but scientists have studied the vision of animals and have a good idea of what they react to.

Few animals outside of primates seem able to see color to the degree that we can, though they probably do not see the world as if it were a black-and-white photo either. Most likely they see very different things than we do, largely responding to the immediate needs of their world. Many birds have extremely good eyesight; a hawk circling high above a meadow can see a mouse wending its way through the grass. Some scientists believe that a hawk's eyesight has eight times the acuity of human vision over small areas.

Many animals can see in the dark much better than we can. Some animals, such as cats, have eyes with different sensors in them compared to people, giving them the ability to see in light levels so low that we would be blind in a similar environment. Bats use high-pitched sounds to act like radar to give them a very strong "vision" of the world around them, even though that is not seeing in a traditional sense.

Insects can sense a whole range of things that we can't. Bees and butterflies actually see a different spectrum than we do. They are able to see ultraviolet light and, therefore, can see patterns on flowers that are invisible to humans. Insect sense organs detect things such as odors that we could never smell, and temperature gradients that we don't even notice. This information has a dimensional quality to it, almost like seeing, yet it is no vision that we recognize. A mosquito, for example, can sense minute quantities of carbon dioxide as well as weak temperature gradients in order to find a warm mammal for blood.

We don't literally see infrared or black-and-white scenes when we look out over a landscape, but black-and-white and infrared photographs show us new visions of the world that are not limited by our senses. Perhaps this is one reason why they are so appealing.

Top: Vineyard in Napa Valley, California

Middle and Bottom: Yosemite National Park, California

Connections

Message
11

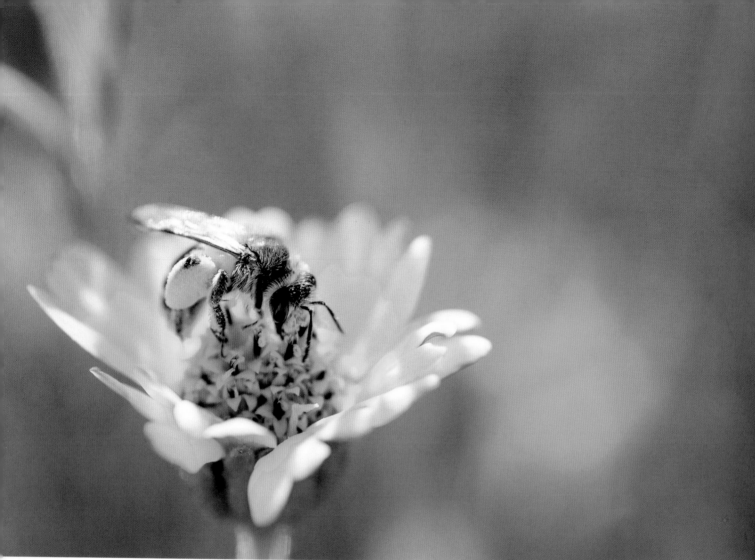

Native bee on San Diego sunflower,
Los Angeles, California

A Message from Our Sponsor

No, this isn't an advertisement. But in a sense, this is a message from our sponsor, the natural world. Nature photographers could not photograph anything if it weren't for nature. Okay, so that's pretty obvious … or is it?

A number of years ago at a meeting of the North American Nature Photography Association (NANPA—www.nanpa.org), one of the sessions included a discussion about photographers and protecting the environment. Many photographers were adamant about environmental concerns and how to be involved with them. But one photographer took strong issue with this approach. This person said all they wanted to do was go out in nature and photograph its beauty. This photographer had no interest in the business of environmental protection as it really didn't affect him.

As you may guess, the group was pretty hard on this individual. This is not an isolated instance. Every time articles were run in *Outdoor Photographer* about environmental issues when I was editor, we got letters saying we should stick to photographing nature and stay out of the nature business.

Overleaf: Ballona Marsh
and surroundings, Los
Angeles (Playa del Rey),
California

It is sad that environmental protection has become political. When I was in college, environmental protection was a bipartisan effort because Americans valued the nature of our country and considered it very important that we protect and preserve it. I think that is still true. Photographers have a role to play by communicating the magic they find in nature through their photographs—magic that deserves to be preserved.

I want to be able to celebrate our beautiful world through photography for as long as I live. I also want my children and grandchildren to have the same chances I've always had to explore and enjoy the wonders of the natural world. Wetlands, for example, are being destroyed at alarming rates. It is noble to want to save the rainforest (and it also deserves attention), but closer to home, the marshes, ponds, and sloughs affect our direct experience with wild America, including the ability to photograph and enjoy wildlife. Policies of our government today cause problems for refuges and parks that will take years to repair, while also costing our children a lot of money.

A sad trend, to me, is the steady reduction in federal funding for parks and refuges in recent years, placing stress on these systems and forcing managers to look for new ways to get money to keep the parks in good shape. This is why new fees are proposed.

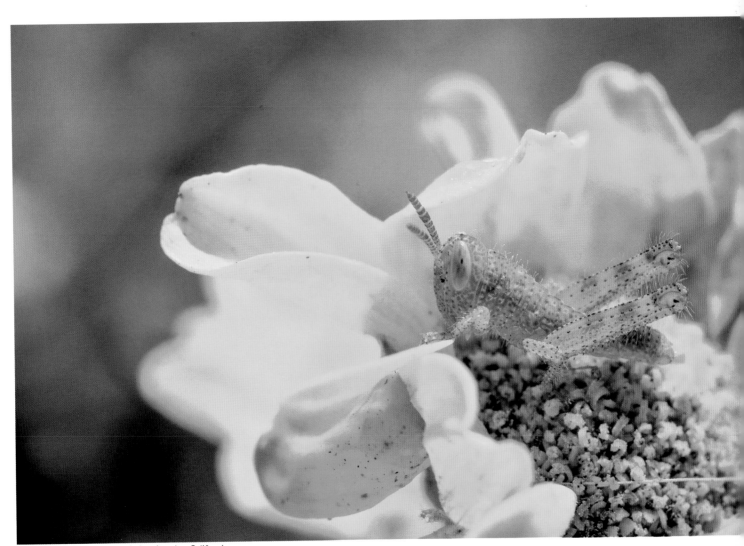

Gray bird grasshopper nymph, Los Angeles, California

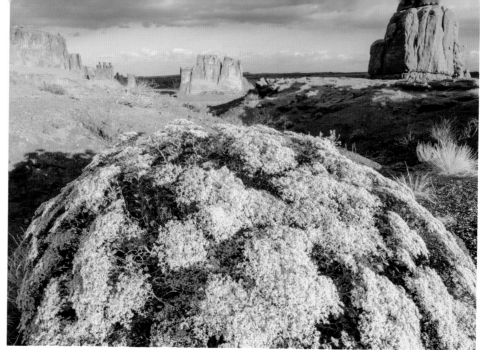

Fremont buckwheat, Arches National Park, Utah

But shouldn't parks be open and accessible to everyone? Shouldn't we, as photographers, have the right to photograph in the parks and refuges that we own as citizens of this country? I think we should have that right, but we also have a responsibility to maintain those places for future generations and for our own photographic needs.

A traditional value of our country since the work of Gifford Pinchot, Theodore Roosevelt, and John Muir in the early 1900s has been the importance of public lands and the federal government's support of them. Our grandparents and their parents made an investment in parks and refuges through the government. That is an investment that I believe we need to build on, not use up.

What happens to all the young people of our country as they become adults and have to deal with fewer natural resources than we have today? Will they be able to experience nature with the richness that we have been privileged to witness and photograph? Will their children be limited in their ability to go outdoors because they suffer from asthma (a chronic problem with strong links to air quality)? Will they have the park experiences we have today, or will parks be damaged beyond repair because we didn't care enough about our kids to take care of our national preserves? Will our children resent us for giving them a financial burden to clean up their world because we didn't do it?

I know there are no easy answers in the very politicized and partisan world we live in today. But as one who has photographed and enjoyed the natural world since I was a kid, I want to leave behind the opportunity for such experiences with my children. What kind of legacy will we offer? A place of broken parks, drained marshes, poisons in our rivers and in the very air we breathe?

It is easy to get caught up in the partisan battles of our elected officials. I don't want to do that. I believe that we can work together, no matter what our political leanings, and make a commitment for keeping our world healthy, strong, and beautiful.

When you see an issue that affects you, let your representatives, senators, and even the President know. It makes a difference when people speak up to their elected officials. You can even share your photos with these people to help them see the magic of nature that is important to you. Also, check out sites such as the Natural Resources Defense Council (www.nrdc.org) to find out about important issues that will affect our use and photography of the outdoors. We can and must take responsibility for clear air, water, and wild places, or they simply will not exist in the future.

Life in Touch with the Environment

Plants are very sensitive to their environment because they are so closely adapted to it. Desert plants don't live in rain forests, and rain forest plants don't live in deserts. The deserts of the Southwest are quite sensitive to environmental conditions. A rainy winter one year will help plants like sand verbena and evening primrose cover the ground, while the same area may be barren the next winter if there is little rain.

While frustrating to photographers, this cycle is an important one for the plants. They need water to grow and reproduce. Though they do this quickly, they still need enough water to ensure they can complete the flower-to-seed process. With enough rain, they "know" they can sprout, grow, blossom, and set seed in time.

The forest is a wetter environment than the desert, to be sure, but both are highly sensitive to limitations of their resources—sunlight for the forest, water for the desert. A forest filled with spring blooms is a joyful sight indeed to anyone wanting a long winter season to end. But the flowers have a very tight schedule to fit their cycle of growth, bloom, and seed. Like all plants, they need light to photosynthesize, create food, and develop. As soon as the forest canopy fills with leaves, the amount of light drops dramatically. Once the foliage fully grows, the leaves might block as much as 90 to 95% of the light that once reached the ground.

Most of our world is governed by cycles strongly connected to conditions in the environment; we are too, to a degree. Animals grow thicker fur when it gets cold; we buy warmer jackets. Since we cannot make food the way plants do, we are affected by changes in the weather as it affects our food crops.

If we make changes, for example such as climate changes that warm the earth in unnatural ways and alter important cycles, we are disrupting patterns that have taken eons to develop. It is worth paying attention to cycles and what is happening to them. The cycle of life and death is the ultimate cycle, and that cycle can easily cease for certain species that can no longer adapt to changing conditions. Because this planet is our only livable ecosystem, this affects us all.

Connections

Canaveral National Seashore, Florida

Index